THE MORE WE LOOK,
THE DEEPER IT GETS

D1224640

THE MORE WE LOOK, THE DEEPER IT GETS

Transforming the Curriculum through Art

Nicola Giardina

ROWMAN & LITTLEFIELD
Lanham • Boulder • New York • London

Published by Rowman & Littlefield
An imprint of The Rowman & Littlefield Publishing Group, Inc.
4501 Forbes Boulevard, Suite 200, Lanham, Maryland 20706
www.rowman.com

Unit A, Whitacre Mews, 26-34 Stannary Street, London SE11 4AB

Copyright © 2018 by Nicola Giardina

All rights reserved. No part of this book may be reproduced in any form or
by any electronic or mechanical means, including information storage and
retrieval systems, without written permission from the publisher, except
by a reviewer who may quote passages in a review.

British Library Cataloguing in Publication Information Available

Library of Congress Cataloging-in-Publication Data Is Available

ISBN 978-1-4758-4466-5 (cloth: alk. paper)
ISBN 978-1-4758-4467-2 (pbk: alk. paper)
ISBN 978-1-4758-4468-9 (electronic)

♾™ The paper used in this publication meets the minimum requirements of
American National Standard for Information Sciences—Permanence of Paper
for Printed Library Materials, ANSI/NISO Z39.48-1992.

Printed in the United States of America

For Anais

Contents

Acknowledgments

For the Astor Educators and students, my inspiration. As one third-grade student said, "You can turn normal things into extraordinary things when it comes to art." Thank you for making learning extraordinary. I wrote this book so that others can benefit from your wisdom.

The art inquiry strategies in this book were developed and shaped by colleagues, past and present, at a variety of institutions including the Brooklyn Museum, MoMA, the Guggenheim, and The Metropolitan Museum of Art. It has been my privilege to learn from so many thoughtful, creative, and generous educators. Thank you for your commitment to making museums inclusive and transformative learning spaces.

For Claire Moore: thank you for your vision, mentorship, and guidance, and for always pushing me beyond my comfort zone into greater possibility.

To my incredible colleagues at The Met: Marie Clapot, Megan Kuensting, David Bowles, Kendra Sykes, Deborah Lutz, and Monique Stanton, for lending their considerable wisdom and expertise to this project.

The Astor Educator Professional Learning Community, initiated and run by The Metropolitan Museum of Art, was launched through seed funding from the Brooke Astor Fund for New York City Education in The New York Community Trust. This fund

was established by the estate of Brooke Astor, who championed education for New Yorkers throughout her life. The program was developed in close collaboration with Claire Moore, with input from William Crow and Sandra Jackson-Dumont, Frederick P. and Sandra P. Rose, Chairman of Education, of the Met's Education Department, and is now an ongoing initiative offered as part of the Museum's extensive educator programs.

For my family: Anthony Giardina for his insight and example, and for encouraging me to take up space. Eileen Giardina for strength and love. Henry Giardina for meticulous transcription. My aunts: Lorraine Judelman, Mary Jane McGovern, and Sheila Bonder Smith for being models of compassionate teaching and service. Joe Giardina for early exposure to art and perpetual encouragement. My sisters: Jill Frutkin, Libby Augarten, Katya Schapiro, Liana Schapiro. Thank you for being my village. Katherine Huala for brilliant art-making ideas and the best art conversations. Neysela DaSilva-Reed for laughter and realness. Maya Valladares for unwavering faith and friendship.

Introduction

A passionate debate is raging among a group of eighth-grade students in The Metropolitan Museum of Art's European Paintings galleries. The catalyst for their discussion is Artemisia Gentileschi's painting Esther before Ahasuerus *(photo 0.1), which depicts the Jewish heroine Esther at the dramatic moment when she appeals to her husband, King Ahasuerus, in order to save her people from being massacred.*

In their English language arts classroom, these students are reading Shakespeare's Romeo and Juliet, *and their spirited conversation weaves together strands from the play's narrative, details from the painting, and stories from students' own experiences. Their teacher has selected this work of art to deepen and extend her students' engagement with a central question of Shakespeare's play: are our lives determined by fate, or do we have free will?*

After their discussion of this work, the class will visit two other works of art at The Met that align with this theme, and engage with them through sketching, role play, and inquiry-based discussion. Upon returning to the classroom, students will write an essay that makes an argument for fate or free will, incorporating evidence from the literature and art they've explored together.

In their classroom, a group of first-grade students are gathered around an image of a sixteenth-century ivory pendant from the Benin kingdom in Nigeria, which features the face of a woman (photo 0.2).

Their teacher has selected this work of art, along with several others, to support a social studies unit on families. Leaning in to look closely at the pendant, students excitedly share their ideas with each other. Noticing her crown, her fierce expression, and her elaborate hairstyle, they decide that it depicts a powerful woman, possibly a queen.

Their teacher shares information about the pendant: that it does indeed depict a queen and that it was worn by her son, a Nigerian king. After sharing this information, the teacher invites students to look again and consider why the king might want to wear this pendant of his mother.

Hands fly into the air as students share their interpretations: "So she could look after him." "So he could be powerful like her." "So she could help him be a good ruler." Next, students consider who and what in their own lives makes them feel powerful and create their own pendant that will give them power. After creating their pendants, students share with each other. One student, whose pendant includes an image of her grandmother, explains, "My grandma protects me and makes me feel loved." Another student shares why he drew his nephew: "I love to play with him, and I always take care of him. It makes me feel powerful because I can show him how to do things like play basketball."

A class of eighteen- to twenty-one-year-old students enrolled in an alternative diploma program are carefully sketching a nineteenth-century marble and bronze bust of a glamorous woman of African descent titled La Capresse des Colonies (photo 0.3).

Their teacher has chosen this object to illuminate themes of freedom, self-concept, and race in Toni Morrison's The Bluest Eye. After completing their sketches and sharing their observations with one another, students write a letter from the subject of the statue to Pecola, the traumatized young black girl around whom the novel revolves. In their letters, students encourage Pecola to love herself and be comfortable in her own skin, reminding her that "Black Is Beautiful."

This rich conversation continues at the next object, a painting by Harlem Renaissance artist Aaron Douglas that draws parallels between the exodus of enslaved people in Egypt and the struggle for freedom faced by black people in America. Students are asked to identify symbolic imagery in the painting and to consider how these symbols play into the overall theme of the work. As the class shares their

thoughtful interpretations, one student enthusiastically comments, "The more we look at art, the deeper it gets!"

That student's moment of discovery illustrates the power of art inquiry experienced by students and teachers participating in the Astor Educator Professional Learning Community at The Metropolitan Museum of Art.[1] The diverse approaches to integrating art into curriculum and instruction described above are just a few ways that these educators employed art inquiry to enliven their teaching practice and inspire their students. Through inquiry-based discussions, these teachers invited students to make connections between their lives, the curriculum, and works of art from across time and place.

Because works of art have the capacity to engage our full selves, they are some of the most powerful tools we can use to reach our students. Inquiry experiences with works of art have the potential to fulfill the aim of aesthetic education set forth by Maxine Greene: "to empower persons (alone or in a community) to know enough to notice what there is to be noticed. . . . [E]xploring for ourselves sound and movement, color against color, voice against voice, we may well find ourselves transformed."[2] As educators, we know that in order for learning to be truly meaningful, it must engage students' hearts as well as their minds. But how do we achieve this? How can we facilitate dynamic experiences with works of art that transform student learning? The method that this book describes, the Pyramid of Inquiry, is a way to leverage the power of art to help your students grow, both academically and as human beings.

The Pyramid of Inquiry was developed for the Astor Educator Professional Learning Community at The Metropolitan Museum of Art—a three-year, grant-funded project supporting New York City K–12 educators and students in low-income communities (Title 1), special education schools (District 75), and alternative schools (District 79). Our aim was to leverage the unique skills and contexts of museum- and classroom-based educators in order to improve student learning in low-performing schools.[3] The forty-five participating teachers varied in their levels of teaching experience (from two to twenty-five years of

experience), subject areas (social studies, English language arts, visual art, science), and student populations.

While many of the teachers had little or no previous experience with art, they shared an interest in art and a desire to reinvigorate their teaching practice. Using the museum as our laboratory, we collaborated to generate, test, reflect on, and refine teaching strategies that deepened critical thinking skills and brought classroom curriculum to life. Our teaching was grounded in a student-centered, inquiry-based pedagogical approach that is central to contemporary museum education practice.[4] We worked together in professional learning communities to improve our teaching practice through a data-driven method incorporating peer coaching, video-based reflection, and analysis of student data gathered during class trips to the museum.

At the outset of this initiative, our goal was to make a deep and lasting impact on teacher practice and student learning by working intensively with one group of teachers over the course of an entire school year. We set goals that aligned with public school priorities: to increase students' critical thinking skills through experiences with works of art.[5]

What we found through the three years was that the benefits for teachers and students were much greater and more diverse than we had imagined at the outset. Yes, inquiry experiences with works of art can help students develop critical-thinking skills, and there is so much more that they make possible. Experiences with works of art have the capacity to change lives, to open up new possibilities, and to transform teaching and learning.

I recently read an interview with Daveed Diggs, one of the stars of Broadway's *Hamilton*. Reflecting on his experiences as a teenager with the spoken word organization Youth Speaks, he said, "I was really aware, even while it was happening, that the discovery of arts education in my life sort of saved my life. As a kid, you don't have a ton of spaces where you are honored, where what you think is honored, and what you say is revered."[6] Engaging in art inquiry with your students is a way to create this kind of space in your classroom—one where students can bring their full selves and truly see each other and be seen. By combining intellectual, social, and emotional learning, art

inquiry can improve students' academic achievement and make a deeply positive impact on their lives.

The Pyramid of Inquiry framework was born from our desire to understand how students think when they look at art together and how teachers can support and deepen their thinking. Like tools such as Bloom's Taxonomy[7] and Webb's Depth of Knowledge,[8] the Pyramid of Inquiry categorizes student thinking according to complexity. In the first year of our program, we observed forty-five middle school classes during two-hour-long lessons at the museum. We recorded and categorized their comments as they discussed works of art with each other, facilitated by their teacher.

What we discovered was that the arc of an inquiry-based discussion begins with an observation phase, where students are deeply noticing various aspects of the work of art. From here, students begin to infer: to think about what they see and to assign meaning to it. Citing visual evidence to support these inferences is a crucial part of this phase.

Through sharing their ideas and listening to each other, the group begins to develop interpretations about the work of art. When students interpret, they synthesize the strands of the conversation, weaving together their observations, their inferences, and any contextual information the teacher has shared about the work of art. Throughout the discussion, students engage in collaborative meaning making, each contributing to a deeper understanding of the work of art.

After analyzing students' responses, we investigated the specific questions and activities that were most likely to elicit these specific types of thinking skills. This allowed us to identify effective strategies for strengthening students' observation, evidence-based inference, and interpretation skills—strategies that will be shared with you in later chapters of this book.

The Pyramid of Inquiry has been tried and tested by forty-five K–12 teachers working with heterogeneous student populations including English language learners and students with a wide range of special needs: gifted and talented students, students with severe cognitive delays, students on the autism spectrum, students diagnosed with emotional and behavioral

disorders, and students with attention deficit disorder. We also worked with general education and honors/advanced placement students. What we found is that whether students perform high academically or struggle to perform well has no bearing on their ability to think deeply about a work of art, to bring their own experiences and full selves to a work of art, and to engage in collaborative meaning making. All students can do this, if given the opportunity.

The aim of this book is to give you, the reader, tools for creating powerful experiences with your students with art. My hope is that these stories inspire you to incorporate art into your curriculum, no matter who or what you teach, that it gives you the tools to do so effectively, and that you witness a positive impact on your students' lives and learning as a result.

Notes

1. The Astor Educator Professional Learning Community was made possible by a generous to The Metropolitan Museum of Art from the Brooke Astor Fund for New York City Education in The New York City Community Trust.

2. M. Greene and Lincoln Center Institute, *Variations on a Blue Guitar: The Lincoln Center Institute Lectures on Aesthetic Education* (New York: Teachers College Press, 2001), 177.

3. We used New York City Department of Education statistics to identify elementary schools where 25 percent or less of students met state standards on state English exams and high schools where 25 percent or less of students graduated college ready (met CUNY's standards for avoiding remedial classes).

4. R. Burnham and E. Kai-Kee, *Teaching in the Art Museum: Interpretation as Experience* (Los Angeles: J. Paul Getty Trust, 2011).

5. "English Language Arts Standards," Common Core State Standards Initiative, http://www.corestandards.org/ELA-Literacy/. Hosted and maintained by the Council of Chief State School Officers and the National Governors Association Center for Best Practices.

6. Shayla Love, "'Hamilton' Star Daveed Diggs: Slam Poetry Saved My Life," *Washington Post*, July 18, 2016, https://www.washington post.com/lifestyle/style/daveed-diggss-first-stop-after-leaving-hamil ton-a-teen-poetry-slam/2016/07/18/56ac2d6a-4c45-11e6-aa14 -e0c1087f7583_story.html.

7. B. S. Bloom, M. D. Engelhart, E. J. Furst, W. H. Hill, and D. R. Krathwohl, *Taxonomy of Educational Objectives: The Classification of Educational Goals*, Handbook I: *Cognitive Domain* (New York: David McKay Company, 1956).

8. Norman L. Webb, "Depth-of-Knowledge Levels for Four Content Areas," unpublished paper, March 28, 2002, http://facstaff.wcer .wisc.edu/normw/All%20content%20areas%20%20DOK%20levels%2032802.pdf

1

Why Teach with Art Inquiry?

This book describes in detail how to incorporate works of art into your curriculum using the Pyramid of Inquiry. But why should you engage in this work in the first place? What exactly are the benefits of incorporating works of art into your teaching practice? The Astor Educator professional learning communities engaged in critical reflection and analysis of student outcomes throughout the three-year program in order to identify best practices for teaching with works of art and to understand the impact of these practices on student learning. The positive outcomes for students that we found can be grouped into five broad categories: relevance, critical thinking, social emotional, engagement, and differentiation. Each of these five points are discussed in detail below. Throughout the book, I will present examples that elucidate both the why and the how of this approach.

- Art inquiry makes learning relevant to students' lives

 A 2015 survey of high school students by the Yale Center for Emotional Intelligence revealed that the top three emotions teenagers feel in school are tired, stressed, and bored[1]—a perfect recipe for disengagement and apathy. However, in the same survey, the students who believed what they were learning was relevant and meaningful to

their lives experienced more positive emotions in school such as interest, respect, and happiness. The importance of relevance to student learning cannot be overstated. But how can we make content relevant, if connections are not readily apparent? This is where art can play a critical role in linking the interests and life experiences of your students to your curriculum topics.

- Art inquiry improves critical thinking skills
 - The role of art inquiry in developing critical thinking skills is well documented,[2] and in the current landscape of American public education, this may be the most compelling argument for incorporating art into the curriculum for many school administrators. Of course, there are many ways to teach critical thinking skills. Why use art? One unique benefit of using art to teach critical thinking is that it is joyfully rigorous: deeply challenging and at the same time thoroughly enjoyable. As high school social studies teacher Christina Pontikis explains, "There is so much emphasis on 'rigor' in the New York City Department of Education and I always thought that having to create higher-level questioning was a difficult process, but because of the Astor Educator Program at The Met, I learned that traditionally 'difficult' things don't have to be difficult at all if they are approached in new and creative ways. The performance anxiety my students often face melts away when they are simply observing art and gradually analyzing the message."[3] Inquiry experiences with works of art activate students' intrinsic desire to make meaning of the world, strengthening their ability to think deeply and critically.

- Art inquiry develops social emotional skills
 - *If I went to the museum myself, I never would have thought about it like that.* —Georgianna, eleventh-grade student

○ When we investigate works of art together, we learn to see through each other's eyes. Inquiry-based experiences with works of art draw out the unique perspectives of each student while challenging students to consider the views of others. By engaging in this work with students, you are building community within your classroom and teaching essential skills of empathy and understanding. Collaborative meaning making depends on the strength in diversity. The more students notice in a work of art, and the more they bring their own experiences to the work, the deeper their collective understanding grows. As Georgianna discovered, looking at art with a group can be so much more meaningful than looking on your own. Inquiry experiences with works of art give all students opportunities to be heard and valued. Through exploring works of art together, students gain confidence in their ideas and their individual ways of seeing the world, while learning to value the diverse perspectives of others. This can have a powerful impact on their lives and academic achievement.

• Art inquiry increases student engagement

○ Art inspires curiosity and wonder. Whether you are bringing your students to a museum or bringing works of art into your classroom, you are introducing them to new worlds and stimulating their imagination. Art inquiry engages students by activating their inherent curiosity about works of art and their desire to make meaning. Unlike many topics covered in school, works of art as topics are not concrete and have no "correct" interpretation. This frees students from the fear of being wrong and allows them to pursue their natural curiosity without boundaries. Art inquiry engages students' emotions, sparks their curiosity, and invites them to bring their full selves into the learning process.

- Art inquiry works for all students
 - As a teacher, you are faced with the incredible challenge of meeting the unique learning needs of many students at a time. In every classroom, these learning needs are likely to be quite diverse. How do you reach them all? Art inquiry is a powerful method of differentiated instruction because it engages students with diverse academic abilities. When students engage in collaborative meaning making, everyone contributes their strengths to the conversation, and everyone's contributions are valuable. A student who is highly verbal may be able to beautifully describe what they see, while a less verbal student may share an important insight about the emotion of the artwork. As students investigate a work of art together, they learn from each other.
 - While this method works for all students, its benefits are perhaps most powerful for students who struggle academically. Countless times after an art inquiry lesson, teachers will turn to me and express their amazement that a student who is normally silent in class, or is reading at a level far beneath their age, had such insight, such enthusiasm, and such articulation when talking about art. For students who have not experienced academic success, art inquiry can be their opportunity to shine.

Keeping these five ideas in mind, let's take a look at an example of the Pyramid of Inquiry in action. Cindy Martinez is a social studies teacher at Facing History High School in Manhattan. Her eleventh-grade U.S. history class is made up of Dominican, West Indian, and West African students. The majority of her students are English language learners and several have individualized education plans for a range of special needs. Cindy chose this particular class to participate in the program because of their low academic performance. Engaging her class in learning U.S. history was challenging, and she wanted to try a

new way to reach them. In this lesson, the class visited The Met during a unit on the Reconstruction period. Prior to the museum visit, students learned about the aftermath of slavery and the challenges African Americans faced after emancipation. Cindy's essential question for this unit was: *What are the consequences of dividing a society into hierarchies?* For the museum lesson, she chose Winslow Homer's *The Gulf Stream* (photo 1.1), a painting made in 1899 of a black man in a rudderless boat, surrounded by sharks and an impending (or retreating, depending on your perspective) storm.

Her question sequence began with asking students to observe the painting closely and find something that they find surprising, interesting, and troubling.[4] After writing down their ideas, Cindy invited students to share their observations with each other.

Cindy: What did you find interesting in this painting?

Student: He's a slave, he's risking his life to be free.

C: What makes you say that he's enslaved?

S: He's black, his clothes are torn.

S: The sharks are all around him.

S: He's just there, he doesn't look worried.

C: What makes you think that he doesn't look worried?

S: He's lying down, his body looks relaxed and calm.

C: What do you find surprising?

S: I see another boat.

C: Why is that surprising?

S: Because he's by himself, and there's another boat, so he shoulda got some help or something.

C: What's the difference between the boat he's on and the one in the background?

S: His is about to fall, it's broken, the other one is bigger.

C: What did you find troubling?

S: He's all alone, there's no one around him. If he's a slave try-ing to get free, he's all alone with no one to help him.

S: That red part, I think that's blood.

S: It looks like there's blood on his foot. But he doesn't look like he's in pain.

S: Maybe he's used to it.

Next, Cindy asked her students to pretend they are the person in the painting and imagine what he might be thinking. After writ-ing their responses, students shared with a partner.

S: I made it through the storm.

S: I'm free but I'm stuck, along with the sharks; I feel hopeless.

S: I survived, but I lost my friend.

C: What did you find surprising, interesting, or troubling about what your partner wrote?

S: Some people look at this painting and feel hopeful, but others are depressed.

S: I was thinking, how am I gonna eat and my partner was thinking, how will I survive?

S: I wrote that I'm depressed because life is so difficult, but my partner said, "Yes, life is difficult but I'm proud because I made it. I escaped; I have my freedom."

C: What do you guys think this painting means?

S: It shows what African Americans had to deal with in order to feel that they were free.

C: Do you see anything in the painting that might be a meta-phor for what African Americans had to deal with?

S: Struggle.

S: Hunger, not having enough to eat.

C: What could the sharks represent?

S: White people.

S: The KKK.

S: Even though he's free, there are people out to get him.

C: The artist, Winslow Homer, painted this in 1899 during the Reconstruction era. How does this painting comment on divisions in society at that time?

S: It's about how people in power oppress those without.

S: Segregation—he escaped. He's out of slavery, but he's by himself. He has less rights than the people in the big boat.

S: But his boat is pointed toward the big ship. It's hopeful.

S: Yeah, the painting goes from dark to light, so maybe it shows hope.

Cindy concludes the conversation by thanking the students for their contributions before moving to the next painting they will explore together.

Let's take a deeper look at how the students engaged with the painting during this twenty-minute discussion, and how their responses relate to the benefits of art inquiry as outlined above.

Critical Thinking

Students' responses built from observation (his clothes are torn, the sharks are all around him), *to evidence-based inference* (he doesn't look worried / he's lying down, his body looks relaxed and calm), *to interpretation* (it shows what African Americans had to deal with in order to feel that they were free).

- Students identified metaphors in the work of art and considered what they might represent: *the sharks could represent the KKK.*
- Students synthesized their ideas and information about the work of art to arrive at interpretations: *It's about how those in power oppress those without.*
- Students made connections to their curriculum: *[It's about] segregation—he escaped. He's out of slavery, but he's by himself. He has less rights than the people in the big boat.*

Relevance / Social Emotional Skills

- Students considered multiple perspectives, including that of the central figure in the painting as well as those of their classmates: *I wrote that I'm depressed because life is so difficult, but my partner said, "Yes, life is difficult but I'm proud because I made it. I escaped; I have my freedom."*
- Students built on each other's ideas: *S1: But his boat is pointed toward the big ship. It's hopeful. S2: Yeah, the painting goes from dark to light, so maybe it shows hope.*

Now let's consider how Cindy created this art inquiry lesson. She began with her curriculum in mind. Her first step was to find an image that could support her unit on the Reconstruction era and to help students consider her essential question: *What are the consequences of dividing a society into hierarchies?* Cindy selected Winslow Homer's *The Gulf Stream*, an image that directly connected to her theme of Reconstruction since it was painted during that era. In addition to the strong curricular connection, the painting has a captivating narrative and lots of visual interest.

After selecting her image, Cindy used the Pyramid of Inquiry to plan a sequence of open-ended questions and activities to support a deep investigation of the painting. She began the inquiry experience by inviting her students to look closely at the painting and to write down their initial responses. By asking students to identify things in the painting that surprised, interested, and troubled them, she hooked her students in with a task that sparked curiosity (there must be something interesting, surprising, and troubling about this work of art!). She then invited students to share their ideas with the group in order to gather their observations. As students shared their responses, Cindy prompted them to point out specific evidence from the painting that supported their inferences (*what do you see that makes you say he's enslaved?*).

Next, Cindy invited her students to step into the painting by imagining they were the central figure. This activity engaged students' perspective-taking skills and asked them to infer the figure's emotions and attitudes based on evidence in the

painting. In sharing their monologue with a partner, they were challenged to consider yet another viewpoint. This was evident when one student shared this: *I wrote that I'm depressed because life is so difficult, but my partner said, "Yes, life is difficult but I'm proud because I made it. I escaped; I have my freedom."*

After hearing from several students, Cindy asked students to synthesize their observations and inferences in order to interpret the meaning of the painting. When one student shared *it shows what African Americans had to deal with in order to feel that they were free*, Cindy prompted students to go deeper by finding metaphoric imagery in the painting that could support this interpretation. At this point, she shared some background information about the artwork: that it was painted in 1899, during the Reconstruction era. She then asked students to take another look at the painting and consider how the painting comments on divisions in society at that time.

Reflecting on the visit, Cindy said, "Art can say so much, and it's more accessible than text; it captures everyone's attention. I work with students with disabilities and English language learners, and text can be complicated for some of them, whereas with an image, they can see themselves in it, they can make observations and point out evidence, and they can start to make interpretations. And once they are able to do that with an image, they are able to build on it when they write. Art is a way to really engage all students. I think that art has so much power: beyond the image, there's so much content, so much history, so much emotion, and you can really connect art to any subject matter."[5]

In the next chapter, we will explore the Pyramid of Inquiry in depth, delving into each of the three categories: observation, evidence-based inference, and interpretation. Excerpts from art inquiry conversations with K–12 students will be included throughout, to provide examples of what each category sounds like in practice. As in the example lesson above, this book includes an analysis of how students responded during the art inquiry lesson as well as how the teachers elicited those responses.

The subsequent chapters will walk you through each step of planning and facilitating an art inquiry experience using the Pyramid of Inquiry. In the final chapter, you will find tools, in-

cluding a Pyramid of Inquiry lesson plan template and sample lesson plans from exemplary teachers. In addition, resources will be provided, as well as suggestions for selecting art images to use in your classroom. Upon completion of this book, you will be prepared to leverage the power of art to transform your curriculum, your teaching practice, and your students' learning.

Notes

1. G. Toppo, "Our High School Kids: Tired, Stressed and Bored," *USA Today*, October 23, 2015, https://www.usatoday.com/story/news/nation/2015/10/23/survey-students-tired-stressed-bored/74412782/.

2. M. Adams, S. Foutz, J. Luke, and J. Stein, *Thinking through Art: Isabella Stewart Gardner Museum School Partnership Program Year 3 Preliminary Research Results* (Annapolis, MD: Institute for Learning Innovation, Annapolis, MD, 2007), https://www.gardnermuseum.org/sites/default/files/uploads/files/Year_3_Report.pdf; D. H. Bowen, J. P. Greene, and B. Kisida, "Learning to Think Critically: A Visual Experiment," *Educational Researcher* 43, no. 1 (2014): 37–44.

3. Christina Pontikis, conversation with author, June 6, 2016.

4. "S-I-T: Surprising, Interesting, Troubling," Facing History and Ourselves, accessed February 19, 2018, https://www.facinghistory.org/resource-library/teaching-strategies/s-i-t-surprising-interesting-troubling.

5. Cindy Martinez, conversation with author, June 6, 2016.

2

The Pyramid of Inquiry

The Pyramid of Inquiry is a flexible framework for creating art inquiry discussions that foster higher-order thinking skills. Educators teaching in diverse contexts can use the Pyramid to plan and facilitate successful art inquiry discussions in the museum and/or in the classroom. When engaging in art inquiry discussions using the Pyramid of Inquiry, students' thinking progresses from observation (what they see), to evidence-based inference (what they think about what they see), concluding with interpretation (what they think the artwork is about). Each phase of the Pyramid is critical to scaffold student thinking as they progress from observing a work of art to interpreting it.

The foundation of the Pyramid of Inquiry is **observation.** In this phase of the conversation, students look closely at a work of art in order to gather information.

Observation question: What do you notice?
Observation: I see a girl wearing a blue dress.

The next level of the Pyramid is **evidence-based inference.** In this phase of the conversation, students think about what they see, forming ideas about the work of art that are grounded in visual evidence.

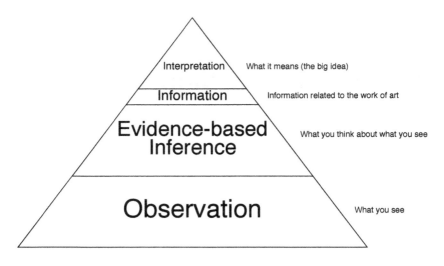

The Pyramid of Inquiry

> Evidence-based inference question: How do you think the girl is feeling? Why?
> Evidence-based inference: I think she's sad because her eyes are looking down.

The summit of the Pyramid is **interpretation.** In the interpretation phase, students synthesize their observations and evidence-based inferences with information about the work of art in order to develop a well-supported argument about its meaning.

> Interpretation question: What do you think this artwork is about?
> Interpretation: I think it's about bullying, because the girl is alone and her friends are not playing with her.

Let's look at two examples of how the Pyramid of Inquiry looks and sounds in practice.

Fèlix Portela teaches art at an elementary school in Washington Heights. During a lesson on sculpture, Fèlix brought his second-grade integrated co-teaching (ICT) class—a mix of

students with special needs and general education students—to The Met to see Edgar Degas's *The Little Fourteen-Year-Old Dancer* (photo 2.1).

The sculpture stands in the center of a small gallery devoted to Degas's paintings of ballerinas. As the class filed into the gallery, they immediately began making balletic movements with their bodies. Fèlix began the lesson by inviting his students to walk around the sculpture in order to view it from multiple angles. Once the students had circled the sculpture, Fèlix asked them to choose a spot where they could observe the sculpture and to sketch the ballerina's pose in their sketchbooks.

After sketching for several minutes, Fèlix asked his students to share their initial observations and any questions they had about the sculpture. Students noticed her clothing and her pose, and wondered how old she was and if she was a famous dancer. Next, Fèlix invited students to pose like the ballerina and to imagine what she might be thinking and feeling. His students enthusiastically contorted their bodies to match the pose of the sculpture before them. Once they had imitated the dancer's pose and facial expression, the students shared their ideas about how she felt. Opinions diverged, ranging from serious to sad to excited. After each inference, Fèlix asked students to identify evidence of that emotion in the dancer's pose and facial expression.

As the conversation built, Fèlix pushed his students' thinking further by sharing the title of the artwork and asking an interpretation question: *What do you think we can we learn about this dancer from looking at her?* To answer this question, students synthesized their observations and inferences about the sculpture to arrive at an evidence-based interpretation of the work of art as a whole. Students responded: *"She's positive and she believes in herself." "She's serious, she's ready to do ballet."*

In this brief conversation, second-grade students looked closely and engaged with the sculpture in multiple ways, building on each other's observations and inferences to eventually come to some well-supported interpretations about what the sculpture expresses. Let's take a closer look at how Fèlix used the Pyramid of Inquiry to support and encourage his students' thinking throughout the inquiry discussion.

Observation: Fèlix began the inquiry experience by engaging students in close observation. He facilitated close looking by directing students to walk around the sculpture so that they were able to observe from multiple angles. Next, he invited them to sketch from observation, a task that demands meticulous observation. After giving students time to sketch, Felix initiated the discussion by asking, *"What do you notice about this sculpture?"* Students responded by sharing their observations: *"She's wearing a tutu," "she's standing tall," "she's looking up at the ceiling."* Fèlix also invited students to share any questions they had about the sculpture, based on their initial observations.

Evidence-based inference: In the next phase of the discussion, Fèlix invited students to pose like the ballerina in order to develop evidence-based inferences about *The Little Fourteen-Year-Old Dancer.* As they posed, he asked them to take the information they gathered from the pose and to think about what the dancer's facial expression and body language communicate. His students had different ideas: some thought her expression was sad, while some thought she looked excited. However, each student was able to support their inference with visual evidence from the sculpture: "She's excited because she's about to dance." "She's sad because her mouth is in a straight line."

When students shared an inference without providing evidence, Fèlix encouraged them to support their ideas with visual information by asking, "What do you see that makes you say that?" By instructing students to imitate the dancer's pose, Fèlix invited them to use a different modality, their bodies, to gain deeper insight into the sculpture. This nonverbal approach supported the diverse learning needs of the class by providing an additional way to build and express their understanding.

Interpretation: Finally, Fèlix pushed his students to think even more deeply by asking them to interpret the work of art. His interpretation question, *What do you think we can we learn about this dancer from looking at her?* prompted students to synthesize their observations and inferences to come to a well-supported argument about what they think a work of art expresses. Students' interpretations spoke to the larger ideas and meanings that the sculpture might embody: *"She's confident—no one can*

laugh at her." "She doesn't care about bullies." "She's proud because she's good at something."

In order to interpret the sculpture, Fèlix's students applied their own prior knowledge, experiences, and feelings to the visual information they had gathered. While Fèlix's students' interpretations reveal more about their own feelings and concerns than perhaps those of Degas's, this is perfectly appropriate. In an art inquiry discussion, there is no "correct" interpretation; all interpretations are valid if they are based on visual evidence from the work of art. The goal of an inquiry experience is not to teach art history (although students will learn the skills of an art historian through this process). The goal is to support higher-order thinking and to forge meaningful connections between students' lives, academic curriculum, and works of art.

Let's take a look at another example of the Pyramid of Inquiry in action, this time with a high school class. Darnese Olivieri teaches English language arts in Bushwick, Brooklyn. The following transcript is from her eleventh-grade honors students' first trip to The Metropolitan Museum of Art. Prior to the museum visit, the class had been reading American literature and exploring the essential question "What does it mean to be American?" Darnese chose George Tooker's *Government Bureau* (photo 2.2) because of its compelling narrative and connection to her theme. Darnese skillfully orchestrates the art inquiry discussion as it progresses from observation to interpretation, using simple questions and techniques to elevate her students' thinking.

> Darnese: As you guys know, we have been talking about American culture and American society. We're here today because we want to look at this painting. Take the next sixty seconds, as we've done when we observe, we infer, and then we interpret. Right now, just observe for one minute. Don't write anything down, just take in the painting. If you're having trouble seeing it, take a step closer to take a look at it.

{Students observe for one minute.}

> D: Now you have in front of you a worksheet that has three columns: "I see," "I think," "I wonder." We are going to begin

with the first column, "I see." Write as much about what you see as you can.

{Students write for one minute.}

D: Now I want you to underline or circle one thing you saw that stands out to you. We're going to "popcorn" around. When we "popcorn" around every kernel must pop, which means no going twice until everyone has shared. Go!

Student: There's resemblance between the people in it.

S: They all look the same.

S: Very crowded.

S: I said repetition that everyone looks the same.

S: I said they all dress the same.

S: The windows have broken glass.

S: Golden color palate.

S: They're all wearing trench coats.

S: Their eyes. They're peeking through a gap.

S: They're all wearing the same color of coats.

S: The people in the booth look really tired; they're not really looking at what they're doing. Just staring.

S: The people inside look old, like they've been there for a long time.

S: The people in the booth look like they're on a computer and doing something while they're talking to the other people.

D: Has every kernel popped? Everyone shared? Okay. We're going to shift to the "I think" column. Now, based on your observations, what do you think about this painting? What can you infer about what's happening in this painting? And next to the "I think" column, there's a column for evidence. I want you to indicate after you write what you think, what evidence speaks to that. I'm going to give you sixty seconds. If some of you get stuck, what are you curious about? What does it make you wonder?

{Students write for one minute.}

> D: Okay, I'm going to call on a random student and what I want you to do is I want you to share what you think, and identify the evidence that supports what you think, and then you're going to pass it to the next student.

> S: I said that it looks like the people in the glass. They're like on display like fishes, because the way that it's green; you know when the fish tank is like dirty, it turns that green color.

> S: I feel that the faces inside the booth are stressed out from the workplace and I assumed it because of the discouraged look they have in their eyes.

> S: I believe they're in an airport, because I feel like this is like, a well-balanced world, because mostly it looks like males wearing the same thing, with the females as well.

> D: What about the image makes you feel like they're in an airport specifically?

> S: I feel like that's a computer and they're giving a ticket or something. And they're looking overworked, they look tired in their eyes and expression. The nose is tensing; it's kind of red.

> S: I said that I think these people are there for something, and it might be something secretive based on the facial expressions of the men behind the windows. And I think it's secretive mostly because the windows are like, it's a long window and there's just one part of it that's a little circle and some of the men don't show their whole face. Some have one eye out; some have half of their face out.

> S: I put that this painting is mainly based on people's desires, and I think that's what's going on in the picture because sometimes we have to live up to other people's criteria and that's what's going on because everybody, like, if they liked their job they wouldn't be so down, they wouldn't be so sad.

> S: I feel like this painting portrays the boredom of their workplace, because of the lack of interest that the people behind are showing, and how every two people, the people look the same, and yeah.

D: Okay, I'm gonna pause you. I didn't tell you the name of this painting at the beginning on purpose. The name of this piece is *Government Bureau*. Knowing that, I want you to write in the last column what you wonder. What are you curious about, what are you puzzled about, what are you confused about.

{Students write for one minute.}

D: What's one question that you have about this piece?

S: Um, I don't really have a question but something that I could say about it is that it's like any other office, and basically like, you don't know what's happening.

S: I said I wondered why all these people are there and why they all dress the same. I said maybe they're a criminal organization. They're like, all together.

D: What in the painting would make you think that they're criminals?

S: Their trench coats, and they look like Italian mobsters.

S: I wonder if these people are standing on line waiting to receive some type of government help, like, for example, food stamps or something. They're trying to receive something from the government.

S: I said something similar. I think that maybe I wonder if they're there to collect money or something from the government.

S: I was like, why did the artist make everyone the same?

S: It gave me, knowing the title, it gave me another perspective and point of view, because now that I know it's a bureau I have an image that they're secret agents and are coming through this government place. And the people inside look tired and stressed, but that's because they're in the government and they know all these types of things, and it's hard to know stuff like that because it's top-secret stuff.

D: So, just gonna make sure I hear what you're saying: now that you know it's the government, the reason these people are here could be top secret, it could be elusive government activity happening, but you can tell that they're tired and it's

mundane and that it's the same thing happening over and over again. Okay. So last question. How would you describe this artist's perspective on American life? Think about the things you saw, the things you thought, and the questions that came up. Not just your own, but the entire class's. Consider what you heard people see, what you heard people think, and what you heard people question. Use the notes you have to come up with an interpretation. What's your interpretation of this artist's perspective on American life?

S: I think he or she thinks that everybody is, like, robots, doing the same thing and, like, the guys in the booths, they have shades on, so I'd say he or she thinks that everybody's the same and nobody's making a difference to make themselves unique.

S: The artist's perspective is one of boredom, and he feels that every day is a mundane ritual for us being ruled and led by our government.

S: I wrote people become so stagnant doing the same thing over again every day.

S: I think the artist is trying to portray the long working life that some workers go through—having a long day, as you said this is a bureaucracy—and sometimes you have to wait countless hours.

D: So that's what American life is?

S: Long and stressful sometimes.

S: I think he thinks the government makes people work to the point where they have no sort of inner lives, and meanwhile there's other people who don't have to work hard and are just there to collect the easy way.

S: I think the artist sees American life as very mundane and ordinary.

S: From the title of the piece, I think that the artist tried to convey that the government is assembled to keep order by having, by keeping an eye on every individual.

S: Based on facial expressions, the artist doesn't think of America that well. The painting shows people that are coming

from something or somewhere they already know, to this new government that's made to seem boring, ugly, or frustrating.

S: The author tried to say that American life is boring, and that so many people try to achieve the same goal, and no one is themselves; we're just all a clone of everyone else.

D: Very nice. From what I just heard, a lot of your interpretations overlap. They're layered and connected. Did anyone have an interpretation that's different from that?

S: I said that the artist thinks that Americans have secrets that drown them.

D: What evidence supports that?

S: The fact that they're all dragged down and look tired, and everyone's hidden.

D: Does anyone else have a different interpretation?

S: I feel like they're tired of dealing with other people's emotions. All the people in the line could be arguing for something they want, and the people just have to continuously shut them down. And it's so sapping. That's why the people in the back are portrayed that way.

D: So can I say that, as a class, for the most part, our interpretation of the piece in terms of what it says about American life— about us as a people, a society, a country—is that this artist's perspective is we are not individuals, and that the government keeps us all the same to keep us in control, and that drowns us and makes us weak, it makes us hunched over, small, tired, stressed. And therefore we don't enjoy the lives we live, but we just live them, with long hours, long days, boredom. Can we say that that's a fair assessment of what we think?

S: Yes.

D: Awesome. You guys did a great job.

In this art inquiry discussion, Darnese's students began with observation, built to evidence-based inference, and concluded with some thoughtful interpretations of the work of art. Let's reflect on how Darnese successfully employed the Pyramid of Inquiry to create this learning experience.

Darnese began by giving students a silent moment to look. Next, she invited students to organize their thoughts about the painting using "I see, I think, I wonder," a visible thinking routine from Harvard's Project Zero.[1] Rather than have students complete the entire thinking routine at once, Darnese began with observation, asking students to identify and write down what they see in the painting.

Once students had a moment to look closely and record their observations, Darnese invited them to participate in a "popcorn share." This rapid-fire method of sharing ideas increases student participation, eliciting ideas from every student in the class. Students pointed out different details in the painting, including the color palate, the figures' clothing, the setting, and the fact that some of the figures look similar to each other.

Darnese advanced the discussion to the evidence-based inference phase by encouraging her students to think about what they see and to provide evidence for their ideas. Darnese supported her students' evidence-based reasoning skills by inserting an additional column next to "I think" for students to record their evidence. As students shared their inferences, Darnese encouraged them to call on each other rather than waiting for her to call on them, a student-centered approach that builds community among learners.

Next, Darnese provided the title of the artwork and asked students to revisit the painting with this new information: *The name of this piece is* Government Bureau. *Knowing that, I want you to write in the last column what you wonder.* This small piece of information provided a context for the painting that scaffolded students' understanding and supported deeper investigation.

Darnese chose to include this information during the inference phase of the discussion, at a point when her students had shared wide-ranging ideas and were invested in the process of discovery. Had she begun the discussion by sharing the title of the painting, it may have limited students' thinking by providing a narrower lens through which to observe. After sharing the title, Darnese invited students to wonder about the painting, inciting their curiosity, engagement, and independence. The in-

formation Darnese shared and her invitation to wonder primed students for the interpretation phase of the discussion.

Finally, Darnese asked an interpretation question that directly connected to her essential question *What does it mean to be American?* The interpretation question, *How would you describe this artist's perspective on American life?* required students to synthesize their ideas about the painting in order to come up with a well-evidenced conclusion about the artist's intent. Darnese reminded her students to consider each other's ideas: *Think about the things you saw, the things you thought, and the questions that came up. Not just your own, but the entire class's.*

Students drew from the class's observations and inferences as well as the information they gleaned from the title of the painting to develop interpretations: *"I think he thinks the government makes people work to the point where they have no sort of inner lives, and meanwhile there's other people who don't have to work hard and are just there to collect the easy way." "The artist's perspective is one of boredom, and he feels that every day is a mundane ritual for us being ruled and led by our government."* As students shared, Darnese encouraged diverse perspectives by asking this: *Does anyone else have a different interpretation?* Her encouragement maintained a spirit of investigation and ensured that the conversation remained open-ended.

To draw the discussion to a close, Darnese chose to summarize her students' interpretations. The strength of this approach is that it can make students feel heard and their ideas validated, and it emphasizes the collaborative meaning making that is central to art inquiry. The danger of summarizing is that some students may feel that their ideas were excluded or disagree with the summary. Darnese mitigated this possibility by including many perspectives in her summary, and asking for student feedback by asking this: *Can we say that that's a fair assessment of what we think?* In this case, Darnese's students agreed with her summation.

This art inquiry experience activated students' minds and validated their unique ways of thinking. Their inherent fascination with the painting and Darnese's skillful use of the Pyramid of Inquiry led to a rich process of discovery. Each student

brought their own prior knowledge and individual perspective to the discussion, which inspired each other to see and make meaning of the painting in new ways. The discussion expanded their thinking about what it means to be American and provided new ways to understand their curriculum.

As these examples show, the Pyramid of Inquiry is an effective framework for creating joyfully rigorous learning experiences with works of art. Each of the teachers featured in this book used the Pyramid for different goals, connecting to various curriculum topics and responding to the unique learning needs of their students. In the three chapters that follow, we will delve into each level of the Pyramid of Inquiry—observation, evidence-based inference, and interpretation—learning from student and teacher exemplars and discovering best practices for developing art inquiry lessons that engage students' minds, bringing forth new ways of thinking and knowing.

Note

1. Patricia Palmer, David Perkins, Ron Ritchhart, and Shari Tishman, "See Think Wonder: A Routine for Exploring Works of Art and Other Interesting Things," Harvard Project Zero: Visible Thinking Routines, accessed February 19, 2018, http://www.visiblethinkingpz.org/Visible Thinking_html_files/03_ThinkingRoutines/03c_Core_routines/See ThinkWonder/SeeThinkWonder_Routine.html.

3

Observation

What You See

The Pyramid of Inquiry begins with *observation*. When students observe a work of art, they spend time looking closely in order to gain information. Works of art reward deep looking, and our experience of a work of art is enriched by the time we spend attending to it. As Georgia O'Keeffe reflected, "Nobody sees a flower really; it is so small. We haven't time, and to see takes time—like to have a friend takes time."[1] To observe deeply requires slowing down and paying attention to what we are looking at, which can be a challenge for us all. Because art is visually stimulating, it draws students in, helping them to discover the pleasure and reward of close looking. Focused observation of works of art support students' skills of noticing and describing, which are critical to all subject areas. When students engage with works of art in focused ways, they become more thoughtful and meticulous observers.

Observation is the foundation of the Pyramid of Inquiry and the critical first step in the inquiry process. There are two key reasons for beginning an inquiry experience with observation. First, the information gathered in this phase will support the development of inferences and interpretations that are grounded in visual evidence. Second, beginning with observation allows all students to contribute to the conversation in a low-risk way, regardless of academic level. Most students are able to describe

or respond to what they see before them in some way. Beginning with observation allows you to set the stage for a truly open-ended discussion that allows for the diverse viewpoints of all of your students.

Without close observation, there can be no meaningful discussion about a work of art. Therefore, the goal for the beginning of any art inquiry experience is always to bring students' full attention to observing what is there. One way to initiate the observation phase of an inquiry experience is to give students a moment to look silently at the work of art on their own before beginning the discussion.

Beginning with silent observation gives students the opportunity to take in the artwork through their own unique lens before engaging in discussion with their classmates. As students observe the work of art, they can write about what they see, sketch, or simply look. There is a meditative aspect to this part of the inquiry experience, as the group silently draws their focus around a singular artwork. After allowing for one to two minutes of silent observation, you can begin the conversation by asking an open-ended question that prompts students to share what they noticed (e.g., What do you notice? What stands out to you?).

In the observation phase of the conversation, your role as a facilitator is to support and encourage students as they gather information about the artwork. The more that students share their observations, the more the group's understanding of the artwork grows. As students share their initial observations, keep the conversation open by asking, "Did anyone notice anything else?" By accepting all students' observations with interest, you affirm their participation and encourage them to contribute their ideas. To guide students' looking and help them focus, you can point to the areas in the artwork that are being discussed.

Let's take a look at an art inquiry lesson that inspired close observation. Lara Tyson, an art teacher in Harlem, brought her fifth-grade class to The Metropolitan Museum to see Jacques Louis David's *The Death of Socrates* (photo 3.1). Her goal for this lesson was for her class, a mix of English language learners and general education students, to understand how artists tell

stories. To begin the lesson, she gave each student a copy of the painting with just the outlines of the figures and challenged her students to find the missing details.

> Lara: The first thing we always do when we're in front of an artwork is to look closely. I'm going to give you a picture of the painting that has just outlines of the figures in it, without any details. I don't want you to pay attention to the figures at first. What I want you to do is fill in the missing objects. So you need to look really closely—it's like a Where's Waldo for objects. You have three minutes to find as many objects as possible.

{Students sketch objects in the painting for three minutes.}

> L: There is no tricking you guys, you're so good at observation! Please raise your hand and tell me about the objects you found.

> Student: A window in the back.

> L: Can you describe the window?

> S: It has bars in it.

> L: It has bars. So keep in mind that object and how that helps you think of where this is taking place.

> S: I think this is taking place in a jail or something. They have a chain.

> S: Somebody persecuted or in prison.

> L: What other objects do you notice?

> S: I see the shackles on the floor. A chair.

> S: I see something in his hand.

> L: So the man in the front with the red, it looks like he's holding something. What do you think is in his hand?

> S: Beer.

> S: Wine?

> L: So you think it's a drink of some kind. What else do you notice?

> S: There's dust.

S: The man is on a couch.

S: In the back, there are people with blocks.

L: Any other objects you see?

S: I see the man wearing the red cloak with a note; there's a scroll next to him.

L: So what makes you think it's a note?

S: Because it looks like paper.

L: Great. So now we're going to do something called a frozen tableau. I'm going to point to a figure in the painting and you guys are going to pose your body like that figure. You don't need to stand up, just move your arms and your head. Let's all sit and put our bodies in the position like that man in the front. Now I want you to act like the man in the red who's handing him the cup. Is your head up or down? The cup should be in your right hand. Act like the guy with both his hands up against the wall. Okay, look at the man in the blue all the way on the right, both his hands on his head.

S: Why's he crying?

L: We're going to answer that in a second. Now look at the figure behind him in the brown cloak. Pay attention to what his hands are doing. And last but not least, can we act like the man in the front? And then total opposite, the man on the right with one hand in the air and one hand on his face. Where is he looking?

S: At the wall.

L: Now that we've looked closely at the objects and the figures, what do you think is happening in this painting?

S: I think that he's in charge of all of them.

L: What makes you think he's in charge?

S: He's the most powerful one.

L: Why does he look powerful?

S: Because he's on the bed. Everybody else is on the ground.

S: I think he's the leader but he's sick so they're getting him all this stuff.

S: It represents how people are scared of him.

L: What makes you think people are scared?

S: Because he's powerful and the people look very scared he's going to do something.

S: Suicide.

L: What makes you say suicide?

S: You see all the people being sad like he's going to do something to himself, to his body or body parts.

L: So what makes you think the guy in the middle is going to do something to his body or commit suicide? Pay attention to those objects.

S: He's giving him something.

S: It's poison.

S: Those chains are something they're going to put on him.

After this student's comment, Lara shared information about Socrates and his choice to commit suicide rather than renounce his beliefs. She invited her students to take another look, comparing their own inferences with their new knowledge of the story behind the painting. From there, she asked her students to interpret the painting by identifying the moral of the story. Students' interpretations included, "Believe in what you believe in" and "Don't give up on your dreams."

Lara concluded the lesson by inviting students to make personal connections to the painting, asking if they agreed or disagreed with Socrates's choice, and whether there was anything that they would sacrifice their own lives for. Students' responses ranged; some agreed with Socrates's decision and cited family and beliefs as things they would give their life for, while others disagreed. Pointing to the other figures in the painting who would be deeply affected by Socrates's death, one student argued, "Because it's other people's lives, it's not just you." Other

students were conflicted, explaining, "It's not as simple as yes or no."

Let's reflect on how Lara supported close observation during this art inquiry lesson.

Focused Observations

Lara broke down the observation process by inviting her students to look closely first at the objects in the painting, and then at the figures. A highly detailed and complex painting like *The Death of Socrates* can be overwhelming at first to students. By looking closely at one aspect of the painting at a time, students were able to focus their attention on specific aspects of the painting. The focus on objects and figures aligned with Lara's theme of storytelling, helping students to develop a narrative based in visual evidence from the painting.

Guided Sketching

A guided sketch, as Lara modeled, is useful for focusing students' attention on particular aspects of a work of art. By framing the activity as a game, Lara engaged her students and sparked their curiosity about the painting. Working with a contour drawing also supports students who are not confident about their sketching skills.

Frozen Tableau

By asking students to take the pose of the figures in the painting, Lara engaged her students physically, giving them another way to access the painting. Posing like a figure in a work of art requires close observation and is a way for students to show

their understanding nonverbally. It also gives students the opportunity to move their bodies, which can stimulate their minds.

Supporting Descriptive Language

Lara supported her students' descriptive language skills by encouraging them to describe what they see:

S: [I see] a window in the back.

L: Can you describe the window?

S: It has bars in it.

L: It has bars. So keep in mind that object and how that helps you think of where this is taking place.

S: I think this is taking place in a jail or something. They have a chain.

S: Somebody persecuted or in prison.

L: What other objects do you notice?

When her students began to make inferences about the work, Lara steered them back to observation by asking, "What other objects do you notice?" This was an effective approach for slowing down the conversation by bringing students' attention back to what they observe.

How Observation Supports Evidence-Based Inference

Lara encouraged her students to use their observations as the basis for evidence-based inferences by asking, "Now that we've looked closely at the objects and the figures, what do you think is happening in this painting?" At this point in the discussion, Lara's students had looked closely at the work of art, gathering details through sketching, posing, and listening to each other's observations. This work prepared them to make inferences based on evidence gathered during the observation phase of the discussion.

General recommendations for observation: Works of art reveal different aspects depending on your physical relationship to them. By taking time to have students see the work of art from various angles, you can support their understanding of the work as a whole. If you are in a museum, invite students to look at works of art from multiple perspectives by walking around a sculpture or looking at a painting from afar before moving close. Museum websites often provide images of three-dimensional works of art from multiple angles and enable you to zoom in to see details, which will help you to approximate this experience in the classroom.

The observation phase of an inquiry discussion should incite students' curiosity and interest in the work of art. Observation questions and activities can provoke wondering and encourage a spirit of investigation.

Observation Questions

- What do you notice?
- What do you notice about (focus on an aspect of the artwork)?
- What do you see?
- Describe (a particular aspect of the artwork).
- What stands out to you?
- What do you notice about the (elements of art: shape/line/color, etc.)?
- What captures your attention in this work of art?

To align your inquiry lesson with your curriculum and goals, develop questions that focus students' observations on particular aspects of the work of art. This will help focus students on the details that align with the goals of the lesson.

Observation Activities

The multimodal activities below support observation skills for students of all ages and learning needs. They provide additional ways of understanding works of art and allow students to respond to works of art nonverbally.

Curious Details

Clare Hagan, a high school English language arts teacher, began an inquiry conversation by asking students to search for "curious details" in a work of art and to mark their observations by placing Post-it notes shaped like arrows on a reproduction of the painting. This prompt focused students' attention and incited curiosity, as students scanned the painting for details that caught their eye and made them wonder. As students shared their "curious details," they became aware of many details in the work of art that their classmates had noticed but they had overlooked.

Eye Spy

In this game, students take turns finding details in a work of art and describing it to their classmates, who listen carefully and scan the painting to find that detail. This approach is highly engaging for your students and supports their descriptive vocabulary skills. Consider using parameters such as, "You must use three descriptive clues to identify your detail" to encourage students to provide specific descriptions.

Focused Looking Game

Divide the class into two groups and assign each group a particular aspect of the artwork to observe. For example, one group could pay close attention to color in a painting, while another could notice figures. Working together in a small group, students focus their attention on finding details related to a specific aspect of the work of art. After investigating their part

of the artwork, each group shares what they noticed with the other group. Often, this approach leads to surprise and wonder, as students point out details that the other group wasn't paying attention to.

Writing Activities

I See, I Think, I Wonder

In the first part of this activity, students make a list of everything they see. This is a good exercise to slow down the looking process for older students, who tend to bypass the observation phase and jump right into inference and interpretation. Once students list their observations, they can move on to list what they think (inference) and what they wonder.

Graphic Organizer

Fold a sheet of paper into quarters to create four boxes. Label each box with a heading and write relevant observations about the work of art in each box. The headings could focus on formal aspects of the work of art (i.e., color, composition, light, brushwork), sensory data (sights, sounds, textures, smells), or other categories aligned with your lesson goals.

Generative Writing

Identify a selection of similar artworks (i.e., five or more landscape paintings) to focus on for this activity. From the designated group, pick one work of art you would like to spend more time with. As you explore the work, create a list of adjectives capturing what you see. Trade lists with another person and search for a work of art that best fits the description you received. Present your selection and rationale to the group. Note—there may be more than one work of art that fits the description you were given.

Sketching Activities

The act of representing visual information requires a high level of observation. Often when students sketch a work of art, they notice details that they may have otherwise overlooked. When sketching with students, it is important to emphasize that the purpose of the sketch is to look closely, rather than to create a perfect reproduction. Begin with simple works of art and progress to more complex ones. You can initiate observational sketching by giving students a prompt such as "Sketch what you notice," or "Sketch four details that catch your eye." These prompts encourage students to capture just the parts of the artwork that stand out to them, rather than trying to reproduce every detail.

Guided Sketching (Shape Sketching)

Even very young children can learn to sketch from observation by identifying the shapes in a work of art. Ask students to identify the largest shape in a work of art and to sketch that shape, moving from large to small shapes and finally adding details.

Viewfinders

In a highly detailed work of art, close observation can be supported through the use of viewfinders, which allow students to "zoom in" on details. Simple viewfinders can be made by rolling up a piece of paper, or cutting a square in the center of an index card. Use a viewfinder to find one detail in the work of art you would like to explore further. Sketch the detail you selected.

Labeled Sketch

Closely observe a work of art and sketch what you see. As you draw, write notes along the perimeter to remind you of key features. Use lines to connect your notes with details in the drawing.

Collaborative Drawing

(If the activity takes place in a museum, select a gallery where there are numerous objects on view in one room.) Select one work of art. Sketch the work you selected for two minutes, then place your paper and pencil on the floor. Move clockwise to the next stop. Pick up the drawing materials left by your peer and sketch the work of art they choose to focus on for two minutes. Repeat this process several times. Return to the drawing you began to see how it developed. Reflect on what you noticed about the featured works and each person's approach to drawing.

Back-to-Back Drawing

In pairs, students take turns being an artist and a describer. The describer will lead the artist, whose eyes are closed, to an artwork, facing them away from it. The describer will describe the artwork with as much detail as possible, while the artist sketches the object based on their verbal description. The artist can ask questions, but may not look at the artwork. Once the sketch is complete, the artist can turn around to compare their drawing to the artwork.

Tactile Renderings

Draw a variety of marks that relate to the textures you see in a work of art. Hint: passing around samples of the materials represented or used in the work of art can help connect with the tactile qualities of each work.

Gesture Drawings

Make quick (thirty seconds to two minutes) drawings of a figure that capture the essential forms of a figure and weight distribution of the body. Compare ways different cultures depict the human figure.

Story Sketching

This activity works with narrative works of art. Students sketch a work of art from observation, and then listen to a story about the work of art. During the story, as students notice details from the artwork that support the narrative, they circle and label those details. This activity is useful for helping students discover key details for themselves and a good way to integrate drawing and visual literacy skills.

As an alternative: Before looking at the artwork, tell students the story and have them visualize and sketch what they imagine as they listen. After listening and sketching, show students the artwork and have them compare their depiction of the story with the artist's.

Guided Sketching for Any Work of Art

Make a simple, contour line tracing of a work of art. Strategically select what to include in this tracing as it will serve as a visual framework to support your prompts as you guide students through the sketching process.

Negative Space Sketching

Create an observational sketch of a three-dimensional object by sketching the spaces in between rather than the form itself. Squinting at the object can help define the negative space.

Observing Works of Art with Art Materials

Students can use various art materials to recreate what they see. Creating a collage, either with scissors or torn paper, can help students observe shapes, composition, and color relationships in works of art. Students can reproduce three-dimensional forms using materials such as aluminum foil, model magic, Legos, or blocks.

Tracing

For older students, using vellum and sharpies to trace images of detailed works of art is a very engaging way to encourage close observation. Students can experiment with combining, repeating, and layering different images to create an original work of art.

Sensory/Movement Activities

Take a Pose

Pose like a figure in the painting.

Soundscape

Imagine that you are inside of the painting. What sounds might you hear? As a group, perform your sounds together to create a soundscape.

A variation for an artwork with parts that make a sound, like a mask, costume, or instrument: Imagine what sounds this object would make. Take turns making a sound and identifying the parts of the object that would sound that way.

Engaging Touch Objects

Art materials: use your sense of touch to gather additional information about the work of art by handling samples of the materials used to create it. Examples of art materials: marble, bronze, gold leaf, pigments in sealed jars, ceramic, wood.

Artists' tools: examine the tools used to create a work of art and consider how they might have been used. Examples of artists' tools: a palate and canvas with dried oil paint, bamboo brushes, a printing block, carving tools.

Texture Bag

Gather materials with textures that relate to the object being viewed and place them in a paper bag. With a partner, take turns placing your hand inside the bag (no peeking!) and describing the texture you feel. Work together to locate a part of the artwork that might feel that way if you could touch it.

Movement Wave

Pick a shape or line in the artwork and generate a word and corresponding movement to describe it. Take turns sharing your word/movements with the group and discussing which part of the artwork inspired it and why.

Note

1. Georgia O'Keeffe and William Einstein, *Georgia O'Keeffe: Exhibition of oils and pastels, January 22–March 17, 1939.* (New York: An American Place, 1939), 2.

4

Evidence-Based Inference

What You Think about What You See

The second level of the Pyramid is *evidence-based inference*. In this phase of an art inquiry discussion, students articulate what they think about what they see, formulating ideas and narratives about a work of art based on visual evidence. The evidence-based inference phase of an art inquiry discussion builds from the observation phase. Students make connections between their observations and their own prior knowledge, using evidence from the work of art to support their ideas.

Christine Sugrue teaches sixth-grade social studies in an integrated co-teaching class with students who are far below grade level due to a variety of learning and emotional challenges.

For this lesson, Christine's goals were for students to build understanding of the characteristics of civilization in Mesopotamia through primary source artifacts and to use visual evidence to support their conclusions.

She chose to teach from two relief panels from Mesopotamia depicting striding lions because of the panels' large scale, brilliant color, and captivating subject matter (photos 4.1 and 4.2). The panels, which each measure 7.5 feet long and 3 feet high, are installed side by side on a large wall. In the beginning of the discussion, the students share their observations about the work of art, quickly building to inference. Throughout the conversation,

Christine encourages the class to use visual evidence to support their inferences.

As the conversation builds, Christine shares information that pushes students' thinking deeper. Toward the end, students apply prior knowledge about the characteristics of a civilization to infer which characteristics they think these panels exemplify, using evidence to make their case. The following is a transcript from their conversation, which took place at the beginning of the year in The Met's Ancient Near Eastern galleries.

Christine: The first thing I'm going to ask is what do you notice about the artifact that we see here?

Student: A lion walking.

S: Maybe he's hungry and angry.

C: What makes you think that the lions are hungry and angry?

S: The face.

C: Maybe his facial expression. What are other things that we see?

S: That the two lions are facing opposite directions of each other.

S: The background is bricks.

C: What does that make you think?

S: That they're in a city somewhere.

C: What else do we notice?

S: It looks like someone is bothering them.

C: You think that somebody is bothering or antagonizing the lions, what makes you think that?

S: Their position on the wall.

C: What else?

S: I think they're guarding something.

C: What makes you think that they're guarding something?

S: Because lions can protect kings.

C: So you associate lions with kings, or queens, or something powerful. Is there anything more we can find?

S: The lions look like they have sharp teeth.

C: We can see those in the lion's mouth. What more can we find?

S: Their hair.

C: Can anyone think of a word for the lion's hair?

S: The mane.

C: The mane is all the way to the lion's stomach. What does that make you think about, this lion's mane?

S: It might give him camouflage.

S: Maybe it means the most powerful lion or powerful creature. I also see arm and leg strength.

C: What things haven't we mentioned yet?

S: They're both in the same position.

C: So even though they're facing in different directions, they're in the same position. What else? What do you notice about the colors?

S: In the background, there's two different colors. At the very bottom stripe, there's yellow and the top stripe's blue.

S: The mane is different from the skin color.

S: That lion looks older than the other one because it looks like it was made before that one.

C: Are you ready to hear some things about the artifact we're looking at? So these lions were part of a relief that led to the city gates of Babylon. A relief is a raised sculpture that's attached to a background. Lions were associated with Ishtar, the goddess of love and war. Now that we have that information, turn and talk to your partner. What might these lions represent?

{Students turn and talk.}

C: What are some of the things you talked about with your partner?

S: The strength of the kingdom.

S: Symbol of a god.

S: Shows how powerful [the goddess Ishtar] is.

S: Bravery.

S: Maybe one means strength and one means intelligence.

S: Maybe one represented love and the other represented war.

S: They're trying to protect the city or they're fighting with each other.

C: So you think they might represent some kind of protection. Yesterday in class, we talked about how artifacts could provide evidence that a place was a civilization. We looked at different characteristics of a civilization. If you don't remember them, I taped them in the front of your sketch pads. You're going to talk with your partner and you're going to see what characteristic of a civilization do you think this relief best shows and why.

{Students turn and talk.}

C: Who would like to tell us which characteristic of a civilization they feel this represents? Which characteristic do we know Mesopotamia had based on this relief? Make sure you tell us why you think that.

S: Social hierarchy because there can only be one dominant one. It looks like they're mad and trying to fight each other to see which one is the dominant one.

S: We thought it was cities, they had giant walls.

C: Since it's on a giant wall protecting the city, there is evidence that they had cities.

S: We thought it was religion because they have the beliefs that it stands for love.

S: I thought it was religion because they're guarding the goddess and religion relates to god, like believing in god.

C: Does anyone have anything else they want to add?

S: I think there were job specialization because it's their job to try and protect the city from intruders.

C: How does this show, what type of jobs might they have had to have this even built? So thinking of job specialization, as people having different jobs in the city: People no longer all have to be hunters and gatherers or farmers produce their food. People can have different jobs. So what jobs might people have to create this?

S: An artist.

S: Designer.

S: Maybe a blacksmith because the lion looks a little bit metal.

Christine supported her students in developing evidence-based reasoning in several ways throughout this conversation. First, she asked for evidence whenever a student made an inference by asking a follow-up question (*What do you see that makes you say that? Or, what makes you think that?*). Asking students to provide evidence to support their inferences keeps the discussion grounded in the work of art. You are not just asking students to share their ideas, you are asking them to draw conclusions based on visual evidence. With practice, students will develop the habit of supporting their ideas with visual evidence without teacher prompting.

Another way that Christine supported her students' evidence-based reasoning skills was by asking students to make inferences based on their observations. For example,

> S: *The background is bricks.*
>
> C: *What does that make you think?*
>
> S: *That they're in a city somewhere.*

And:

> C: *The mane is all the way to the lion's stomach. What does that make you think about, this lion's mane?*
>
> S: *It might give him camouflage.*

S: *Maybe it means the most powerful lion or powerful creature. I also see arm and leg strength.*

In each of the above examples, Christine listened to a student's observation and responded by asking them to think about what they noticed. This prompting helped students advance their thinking from observation to evidence-based inference.

Christine accessed students' prior knowledge of the characteristics of a civilization and asked them to apply this knowledge to the artwork. To respond to this question, students had to infer which characteristic of a civilization they thought the relief represented, using visual evidence to support their argument.

C: *Who would like to tell us which characteristic of a civilization they feel this represents? Which characteristic do we know Mesopotamia had based on this relief? Make sure you tell us why you think that.*

S: *Social hierarchy, because there can only be one dominant one. It looks like they're mad and trying to fight each other to see which one is the dominant one.*

Finally, Christine supported her students' higher-level thinking skills by sharing contextual information about the work of art. After students had the chance to explore the artwork together, and share their observations and inferences, Christine asked:

C: *Are you ready to hear some things about the artifact we're looking at? So these lions were part of a relief that led to the city gates of Babylon. A relief is a raised sculpture that's attached to a background. Lions were associated with Ishtar, the goddess of love and war.*

Rather than end the conversation there, she pushed students' thinking deeper by asking an interpretation question:

C: *Now that we have that information, turn and talk to your partner. What might these lions represent?*

S: *The strength of the kingdom.*

S: *Symbol of a god.*

S: *Shows how powerful [the goddess Ishtar] is.*

S: *Bravery.*

S: *Maybe one means strength and one means intelligence.*

S: *Maybe one represented love and the other represented war.*

Christine also supported her students' linguistic development and encouraged participation throughout the conversation.

In several instances, Christine supported students' language skills by paraphrasing what they said using more complex vocabulary. For example:

C: *What makes you think that the lions are hungry and angry?*

S: *The face.*

C: *Maybe his facial expression.*

She also encouraged students to enrich each other's vocabulary:

C: *What more can we find?*

S: *Their hair.*

C: *Can anyone think of a word for the lion's hair?*

S: *The mane.*

By paraphrasing students' responses, teachers can assist with language development by demonstrating proper sentence construction and inserting rich vocabulary.

Throughout the conversation, Christine encouraged diverse viewpoints and kept the conversation open by asking questions like, *What things haven't we mentioned yet?* She had students turn and talk during several points in the discussion, so that every student had an opportunity to share their ideas.

In an article Christine wrote advocating for museum trips, she reflected, "Almost all of the students that I brought to the museum as part of the Astor program had difficulty with reading, and many of them had attention issues too. Yet they learned a great deal from their experience at the museum. Throughout

the year they gained knowledge of Mesopotamia, Buddhism, and the Middle Ages. They gained an appreciation and respect for art and history. Most importantly, they gained confidence in their ability to learn and share ideas."[1]

Evidence-based reasoning is an essential critical thinking skill that will serve students throughout their lives. Art inquiry provides students with engaging opportunities to think deeply about what they see and to support their arguments with visual evidence.

The following questions and activities can be used in the context of an art inquiry lesson to support evidence-based reasoning skills for K–12 students.

Questions that Support Evidence-Based Inferences

- What's happening in this work of art?
- What do you think is the story?
- What's going on in this artwork?
- What do you think will happen next?
- How would you describe the mood of this artwork?
- How do you think this artwork was made?
- What word comes to mind when you look at the artwork?
- How might this object have been used?
- What do you think the artist chose to emphasize?
- Why do you think the artist chose to (identify an artistic choice in the artwork)?
- What can you infer about the relationship between the figures in this artwork?
- What symbols can you identify in this artwork? What might they represent?

Movement and Drama Activities

The following activities support students' evidence-based reasoning skills through movement and drama:

Take a Pose

Recreate the pose of a figure in a work of art. While in the position, consider what the person might be thinking, doing, or feeling. Share your ideas.

Tableau (Frozen Picture)

As a group, take the pose of the figures in an artwork. Then, imagine what happened just before the scene portrayed in the artwork and what might happen right after. Create three tableaux and perform them for an audience.

Living Sculpture[2]

Select a partner to work with and identify one person who will be the sculptor and one person who will be the "clay."

> **Sculptor**—Position yourself in front of a work of art you would like to focus on. When your partner is ready, use descriptive language to sculpt their body into the shape or pose you see. Once the sculpture is complete, take a moment to reflect on what this form/pose conveys and share your thoughts with your partner.
>
> **"Clay"**—Stand facing your partner (looking away from the featured work of art). As you listen closely to your partner's description, use your body to recreate the form. No peeking until time is called! Once the sculpture is complete, take a moment to reflect on how this pose makes you feel and share your thoughts with your partner.

Artist's Process

Imagine that you are creating this painting. How would you move your body to replicate the artist's brushstrokes?

Writing Activities

The following activities support evidence-based reasoning through writing:

I See, I Think, I Wonder[3]

Divide a sheet of paper into three columns. After looking closely at the work of art, write what you see (first column), think (second column), and wonder (third column). Share your responses with peers and seek out information to address wonderings that can be addressed through research.

Surprising, Interesting, Troubling[4]

Write down one thing you find surprising, interesting, and troubling about the artwork.

Perspective Taking

Write an account of what is going on in a narrative painting from the point of view of a figure, an animal, or an object in the work.

Meeting of the Minds

Select two works of art featuring figures. (Select one figure as a focus from each work if there are multiple figures.) Imagine the two characters met. Write what they might say to each other (as well as what they might think but not say).

Thought Bubbles

Select a work of art with clear figures in compelling poses. Provide students with an image of the work with comic book "thought bubbles" added over the heads of key characters (or simply offer thought bubbles on a sheet of paper). Have students write out what each character might be saying or thinking using complete sentences. Use visual evidence to support these assumptions.

Sketching Activities

The following activities support evidence-based reasoning through sketching:

Symbol/Shape Library

Fold a sheet of paper into quarters to create four boxes. Look closely at several works in the gallery and sketch an interesting symbol, motif, or shape you see in each box.

Before and After

Look closely at the featured work of art and sketch what might come before and/or after this moment.

Evidence Boxes

Fold a sheet of paper into quarters. Look closely at the work of art and sketch one detail in each box that supports an inference. (Prompts such as "Sketch four details that demonstrate ways this community relates to its environment" can provide a useful focal point.) Share your inference and corresponding visual evidence.

Activities Engaging the Senses

The following activities support evidence-based reasoning through engaging the senses:

Sensory Poem

Imagine that you have stepped into this work of art. What do you smell? Hear? Touch? Taste? Create a poem that describes the experience of being inside the artwork.

Handling Materials

Bring materials that relate to the materials and process used to create a work of art. For example, a palate with dried oil paint and a stretched canvas if you are looking at an oil painting, a block of marble and a chisel if you are looking at a marble sculpture. Take turns exploring the materials and making connections to the work of art. How do you think it was made? What do you think may have been challenging about the process? What might be the advantages of working with these materials?

Notes

1. Christine Sugrue, "Day at The Museum? This Teacher Turns Boredom to Excitement." *New York School Talk*, April 18, 2017, http://newyorkschooltalk.org/2017/04/day-museum-teacher-turns-boredom-excitement/
2. Sharon Vatsky, Director of Education, School and Family Programs at the Guggenheim Museum developed this activity.
3. Patricia Palmer, David Perkins, Ron Ritchhart, and Shari Tishman, "See Think Wonder: A Routine for Exploring Works of Art and Other Interesting Things," Harvard Project Zero: Visible Thinking Routines, accessed February 19, 2018, http://www.visiblethinkingpz.org/VisibleThinking_html_files/03_ThinkingRoutines/03c_Core_routines/SeeThinkWonder/SeeThinkWonder_Routine.html.
4. "S-I-T: Surprising, Interesting, Troubling," Facing History and Ourselves, accessed February 19, 2018, https://www.facinghistory.org/resource-library/teaching-strategies/s-i-t-surprising-interesting-troubling.

5

Interpretation

What It Means (The Big Idea)

The summit of the Pyramid of Inquiry is *interpretation*. Works of art are visual metaphors, and interpretation is the act of deciphering their meanings. When students interpret a work of art, they grapple with big questions: *Why was this work of art created? What can it tell us about the time period/culture/society in which it was made? What does it communicate?* Interpretation requires students to synthesize their observations and inferences with information about the work of art to come to a well-evidenced argument about its meaning and/or purpose.

A meaningful analysis of a work of art cannot be formulated without first observing the visual qualities (observation) and considering their significance (inference). In the inference phase of the conversation, students often develop a narrative about what is taking place. Interpretation questions ask students to go beyond narrative to uncover the deeper meaning of the work.

Let's take a look at an art inquiry lesson in which very young students demonstrate interpretation. Valerie Patterson is a gifted and talented kindergarten teacher in South Brooklyn. Her goal for this lesson was for her students to learn how color can be used to communicate emotions through exploring Mark Rothko's painting *No. 16* (photo 5.1).

She began the discussion by eliciting observations about the painting, followed by inferences about how the painting was

made. Students observed the colors and shapes and discussed their inferences about how the colors were mixed together and applied to the canvas. Next, Valerie shared some information about the artist's intent and invited students to share their interpretations of the emotions expressed in the work of art.

> Valerie: The name of the artist who created this painting is Mark Rothko, and he once said that in his paintings, color is not the most important thing for him. For him, it's the emotion, it's about what you're feeling when you look at his paintings. So, having said that, I want you to think about how this painting makes you feel. Think about it for a minute. What are some big emotion words that describe how you feel when you look at this painting? I want to hear from some people who I haven't heard from yet, so just think for a minute.
>
> Student: Relaxed.
>
> V: It makes you feel relaxed, okay. Why do you say that?
>
> S: Because in the picture I see blue.
>
> V: Okay, and what do we know about blue?
>
> S (same as above): It's cool.
>
> S: It makes me feel calm because of the colors and reminds me also of when the flag moves, it makes me feel calm when I look at it.
>
> V: Does the painting remind you of a flag?
>
> S: Yes, the Italian flag.
>
> S: I feel kind of gloomy.
>
> V: What makes you feel gloomy?
>
> S: Because of the black and darkish blue reminds me of a stormy rainy day.
>
> S: It makes me feel moody, because first red you're very energetic and content, then black you get kind of worn out, like if you're playing at a baseball game: at first you're hyped to do it but like then you're doing it, and you're outside in the hot weather a lot too and you get really tired.

V: Okay. So there's a combination of feelings.

S: It makes me feel relaxed and calm.

V: Relaxed and calm because?

S: Because the blue and the red reminds me of the beach, like the red would be the sun, it would be in the sunset, and the blue would be the water.

S: This makes me feel a little scared because the blue reminds me of a tsunami.

V: Ooh, a tsunami. That is kind of scary, do you want to tell everybody what a tsunami is?

S: A tsunami is like a very big wave.

S: It's a harbor wave because the "tsu" means harbor and the "nami" means wave.

V: Excellent. Okay, so let's think about the size of this painting. Why do you think this painting is so big?

S: Um, I think it's so big because the artist wanted to do big shapes of color.

V: Why do you think he wanted to do that for us? Why was it important to have these colors be so big?

S: So he could make the shapes bigger so they could not just express the feeling more, but make the shapes bigger so we could feel more of it instead of, like, in a little painting where you'd just feel excited. In this painting, like, at first you're excited with the red, but then there's a big black so it changes your whole mood.

V: So you're saying he was able to put more emotions into the painting because it's bigger. He could add more stuff to it.

S: I think he made it a bigger painting so it could make a bigger effect on your feeling.

S: I want to add on. I think he made it bigger because he wanted to make a bigger emotion, and like, so, when it would be smaller like, when you would be like, just happy about it, but then to make it a bigger emotion it would be really exciting.

V: Those are some wonderful ideas. The artist wanted you to have a big experience, and he also wanted you to feel like you were part of the painting. Like, when you stood in front of it, he wanted the painting to sort of like, hug you or to envelop you so that you could be part of it.

S: Maybe the artist made it bigger to make your feelings bigger when you express your feelings.

In this part of the discussion, Valerie asked two interpretation questions.

The first interpretation question that she asked was this: *What are some big emotion words that describe how you feel when you look at this painting?* This is an interpretation question because it asked students to summarize the main idea that the painting communicates. In order to support students' interpretations, Valerie provided some information about Rothko, paraphrasing a quote by the artist: "I'm not an abstractionist. I'm not interested in the relationship of color or form or anything else. I'm interested only in expressing basic human emotions: tragedy, ecstasy, doom, and so on."[1]

In most cases, providing information about a work of art is essential to move students beyond evidence-based inference to interpretation. In response to this question, students made associations between the colors they observed and the emotions that those colors made them feel. (*"This makes me feel a little scared because the blue reminds me of a tsunami." "I feel gloomy because of the black and darkish blue reminds me of a stormy rainy day."*) While students' interpretations varied widely, they were each able to support their thinking with visual evidence.

Valerie's second interpretation question, *Why do you think this painting is so big?* asked students to consider the purpose of the painting and the artist's intent. To answer this question, students built upon their ideas about what the painting communicates, thinking about the choices the artist made.

Knowing that the artist wanted to communicate emotions (from the information Valerie provided), students then considered the meaning behind the specific choice to make the canvas so large. Their responses to this question were more convergent,

as students generally agreed that Rothko made the painting large "so it could make a bigger effect on your feeling." In this lesson, they learned how artists make specific choices in order to communicate meaning and to impact viewers' experiences of their work.

Valerie encouraged higher-order thinking by asking big questions and pushing her students to go beyond their initial responses. For example:

> V: *Excellent. Okay, so let's think about the size of this painting. Why do you think this painting is so big?*
>
> S: *Um, I think it's so big because the artist wanted to do big shapes of color.*
>
> V: *Why do you think he wanted to do that for us? Why was it important to have these colors be so big?*
>
> S: *So he could make the shapes bigger so they could not just express the feeling more, but make the shapes bigger so we could feel more of it instead of, like, in a little painting where you'd just feel excited. In this painting, like, at first you're excited with the red, but then there's a big black so it changes your whole mood.*

When this student gave an initial response, Valerie probed deeper by asking her to explain her thinking, which led to a more thoughtful interpretation. Questions such as "Why do you think that?" or "Tell me more" support student thinking by encouraging them to elaborate on their ideas.

Do Works of Art Have Correct Interpretations?

Art inquiry discussions are open-ended, with the goal of supporting divergent thinking. Students often come away from an art inquiry discussion with different interpretations of a work of art, having arrived at their conclusions through a process of looking closely, considering multiple perspectives, and thinking rigorously.

A successful art inquiry discussion is not one in which students arrive at a predetermined answer. As Maxine Greene said, "Arguments, as you well know, come to conclusions. Works of art do not."[2] Great works of art do not have fixed interpretations; they continue to resonate with new meanings over time.

This does not mean that scholarly interpretations or artists' statements should be left out of the art inquiry discussion. They provide valuable insights and context for works of art that support students' understanding. However, these voices should never be presented as the "correct" interpretation. Students should understand that their voices and perspectives are valid, even if they differ from the ways an artwork has historically been interpreted.

Students can be made aware of differing scholarly or critical interpretations of works of art and challenged to evaluate those arguments as well as to make their own. Winslow Homer's *The Gulf Stream* (photo 1.1) is an excellent example.

At The Metropolitan Museum, where the painting hangs in the American Art galleries, its label reads, *Some art historians have read* The Gulf Stream *as symbolic, connecting it with the period's heightened racial tensions. The painting has also been interpreted as an expression of Homer's presumed sense of mortality and vulnerability following the death of his father.*[3] By including more than one interpretation on the label, the museum reinforces the idea that there are many ways to interpret a work of art. Both of these interpretations are supported by scholarly research as well as visual evidence.

Homer himself, when asked to explain the painting, said, "The subject is in the title."[4] During an art inquiry discussion with high school students, I asked them to find visual evidence for each of these interpretations and to engage in debate about which art historian they agreed with. Of course, the interpretations are not mutually exclusive, and it is likely that Winslow Homer was both deeply affected by his father's death and troubled by the racial injustices of the time.

By including both perspectives, students learned that there can be multiple correct interpretations and that artworks continue to reveal new meanings over time. Asking students to

agree or disagree with scholarly interpretations validated their own voices and ability to make meaning of the work. Through experiences like this, students learn to embrace ambiguity and grapple with multiple perspectives. As F. Scott Fitzgerald said, "The test of a first-rate intelligence is the ability to hold two opposed ideas in the mind at the same time, and still retain the ability to function."[5]

Interpretation Questions

While students of all ages can learn to interpret works of art, some interpretation questions are more developmentally appropriate for different ages. In the Astor program, we found that high school students were able to successfully answer questions about artistic intent (e.g., What do you think is the message of this artwork?) while elementary-age students struggled with the concept.

As an adaptation, we asked very young students to give a work of art a new title, a question that was developmentally appropriate for fostering interpretation, as students had to summarize the main idea or message of the work of art in order to title it.

For students of all ages/abilities:

- What do you think is the moral of this story?
- What do you think is the main idea of this artwork?
- What do you think this artwork is about?
- What are some emotion words that describe how you feel when you look at this artwork?
- Why do you think this artwork is (identify an artistic choice, such as scale, materials, colors)?

For older/advanced students:

- Why do you think this artwork was made?
- What do you think is the message of this artwork?
- What do you think this artwork can tell us about the artist who made it?

- What do you think this artwork can tell us about the society it was made in?
- What does this artwork suggest to you about (life, love, relationships)?
- What do you think the artist is trying to show/convey with this artwork?
- What big ideas/themes does this artwork bring up for you?
- What might be the purpose of this work of art?
- (After giving information) How does this information change or confirm your ideas about this artwork?
- How do you think the artist felt about (subject of artwork)?
- What might this painting communicate about life in (location/setting/time period)?
- What might this artwork tell us about the values, beliefs, or cultural practices of the society in which it was made?

Activities that Support Interpretation

For students of all ages/abilities:

- Create a new title for this artwork that communicates the big idea.
- Create your own work of art that responds to/reinterprets the big ideas embodied in the artwork.

For older/advanced students:

- Debate: develop an interpretation of the artwork and defend it. Take turns presenting your argument and listening to classmates' perspectives.
- Write a journal entry from the artist's perspective. Imagine the artist's process and their ideas/feelings about the artwork as it was being created.
- Incorporate texts that relate to the artist/artwork: artist quotes/video, critical reviews of the artwork, historical

documents, and so forth. How does reading the text illuminate the artwork in new ways?

Notes

1. The Museum of Modern Art, *MoMA Highlights*, rev. ed. (1999; New York: Museum of Modern Art, 2004), 196.

2. Maxine Greene, *Variations on a Blue Guitar* (New York: Teachers College Press, 2001), 41.

3. "Heilbrunn Timeline of Art History: Winslow Homer, The Gulf Stream," Metropolitan Museum of Art, accessed February 19, 2016, https://www.metmuseum.org/toah/works-of-art/06.1234/.

4. Peter H. Wood, *Weathering the Storm: Inside Winslow Homer's Gulf Stream* (Athens: University of Georgia Press, 2004), 41.

5. F. Scott Fitzgerald, Edmund Wilson, Gertrude Stein, Edith Wharton, T. S. Eliot, Thomas Wolfe, John Dos Passos, Paul Rosenfeld, Glenway Wescott, and John Peale Bishop, *The Crack-Up* (New York: J. Laughlin, 1945), 69.

6

The Role of Information in an Art Inquiry Discussion

The role of information in an art inquiry discussion is to provide context for the work of art in order to support higher-order thinking. In most cases, students need information about works of art in order to progress from evidence-based inference to interpretation. Information serves as an additional perspective for students to consider as they make meaning of the work of art. The information you share with students should provide new ways of understanding a work of art, rather than an answer or "correct" interpretation.

How you fold information into an art inquiry discussion is critical: if you frontload the conversation with information, you can limit students' opportunity to create their own meanings. If you end with information, you run the risk of making students feel that their interpretations are not valid. The purpose of including information in an art inquiry discussion is to expand students' thinking, never to limit it. As such, information should be presented as another factor for students to consider, along with their own ideas, as they make meaning of the artwork.

In the Pyramid of Inquiry framework, information is usually shared between the evidence-based inference and interpretation phases of the discussion. This allows students to form their own ideas about the work of art without information, which cultivates their curiosity. Students are usually eager to receive information

about the work of art after looking closely and sharing their observations and inferences. Once students have some context for the work of art, they will synthesize this information with their previous ideas to develop well-evidenced interpretations.

The following lesson is an example of how Nicole Feliciano, a sixth-grade social studies teacher, used historical information related to a work of art to elicit higher-order thinking from her students and make meaningful connections to their curriculum.

Nicole developed this lesson as part of a unit on social activism and civic engagement. As a culminating project, her students identified a problem in their community and used art to build awareness and promote civic engagement around that issue. At The Met, Nicole looked for examples of artists whose work related to societal issues. Her search brought her to Jonas Lie's *The Conquerors (Culebra Cut, Panama Canal)* (photo 6.1), a dark and foreboding painting of the construction of the Panama Canal.

While Nicole's students were not specifically studying the Panama Canal, the painting connected to her larger theme of art as social activism as it depicts the unsafe working conditions of the canal. In order for her students to make this connection, Nicole knew that they would need some contextual information about the construction of the Panama Canal. The description that follows illustrates how the inclusion of contextual information in an art inquiry lesson can deepen understanding by illuminating curriculum topics and supporting students' interpretation skills.

This lesson took place in the American Art galleries at The Metropolitan Museum of Art. After seating her class in front of the painting, Nicole invited them to spend some time in silent observation without giving them any factual information about the painting. She encouraged students to look for details by showing them how to roll a piece of paper into a telescope, a technique that supports close observation.

After observing the painting for a moment, students were directed to switch seats with a classmate, so that they could view it from a different perspective. Students who were seated very close to the painting switched seats with those who were seated in the back. Nicole chose to have her students look at the painting from more than one vantage point to deepen their

observation. From afar, the painting looks very different from how it does up close; different aspects of the work are revealed depending on one's physical proximity to the painting.

Once students were settled, Nicole encouraged them to take a second look and to write down an emotion word that they associated with the painting. At this point, students had been actively engaged in observation for almost five minutes. Nicole broke the silence by inviting students to share their emotion words aloud. Students described the painting as chaotic, sad, dangerous, and frightful. Next, Nicole asked students to make inferences about what they thought was happening in the painting.

Several students thought that the painting depicted a train wreck, citing the trains, the people walking nearby, and the smoke as evidence. Others thought that the painting showed a migration of people, who were possibly lost or looking for a new home.

After listening closely to her students' inferences and paraphrasing their responses, Nicole arranged her students in several small groups and distributed information about the construction of the Panama Canal.[1] She instructed her students to read the facts, look closely at the maps and images, and discuss how the advantages and disadvantages of building the Panama Canal were depicted in the painting.

Following the small group discussions, Nicole brought the full class's attention back to the painting. The following transcript shows her sixth-grade students' thinking as they synthesize their ideas about the work of art with the information they read about the canal.

> Nicole: What do you think this artist identified as community problems in Panama at this time?
>
> Student: I think he identified all the trees that are cut down . . . because of all the smoke . . .
>
> N: So you're talking about pollution and destruction of the rain forest and your evidence is the smoke and the lack of trees in that area. What else?
>
> S: I think that there was different pay for different people.

N: What in this painting can help you prove that?

S: In the center of the image . . . they look trapped and tired.

N: What makes you say this is a different people group?

S: I think it's a different people group because of the color.

S: He uses white, dark blue, and brown. There's a lot of black.

N: Ok, so the different colors could indicate different races. The group back there was talking about how those who were nonwhite had lower paying jobs and the people who had lower paying jobs often had the most dangerous jobs. So what do you think would be some of the dangerous jobs based on the painting?

S: People who are building the train tracks.

N: Why do you think that would be dangerous?

S: Because of all the smoke coming out.

S: They're destroying the mountains.

N: You've made some great connections between the painting and the information we just read. What do you think motivated the artist to create this painting?

S: Possibly the construction of the Panama Canal.

N: Why?

S: Because it seems like there was a lot of work going on and judging from the pictures that we see over here and in the painting, it seems like a lot of people were either dying, getting sick diseases, from construction. So a lot of people were dying and possibly making him think about his community in a way that motivated him to draw a picture.

S: I think that, adding on to what Ethan said and what Adrian said, I say that it shows segregation because people were doing jobs that were dangerous and the government didn't want to pay people. Mostly African Americans and Indians and Chinese I think. They were doing that mostly because they were getting paid less and some of them maybe have children; you never know. That child might have a hard life. And I think some people got paid a lot, so that's segregation.

N: So why do you think the artist painted this?

S: I think that he painted this image to show people that it's hard, that some people are being selfish, and in order to make a living the way they want is hard and scary.

By including information about the historical context of the painting, Nicole enabled her students to interpret the work of art and to connect it to larger social issues. In this lesson, the information that Nicole shared with her students was essential to their interpretation of the painting. Without receiving any contextual information about the painting, students were able to make thoughtful observations and evidence-based inferences. Had Nicole chosen not to provide any contextual information about the painting, their conversation would have remained in the inference phase.

Nicole enabled her students to synthesize the emotions they ascribed to the painting (frightful, chaotic), their ideas about what was happening (train wreck, migration), and the information they learned about the positive and negative impact of the construction of the Panama Canal. The information was critical to connect the painting to the larger theme of art and activism that Nicole's curriculum explored. It also led to deeper thinking about the injustices that the painting portrayed and allowed students to interpret the artist's message and intent.

Nicole chose to include information about the Panama Canal because it supported her theme of social issues. The information helped students understand the problems that the painting depicted, which supported their interpretations about the artist's message. For Nicole's goals, biographical information about the artist or information about the artist's process were not relevant and would have steered the conversation in a different direction, away from her curriculum theme.

A potential pitfall that teachers face when introducing information about a work of art is making students feel that their own ideas were "wrong" in light of what they know now. It is important for students to know that their evidence-based inferences are still valid even if they are not "correct." For example, before knowing that the painting depicted the construction of

the Panama Canal, some students thought that it depicted a train wreck, while others thought it represented migration. Looking at the painting, there is ample evidence to support both of these inferences.

To validate students' previous ideas and keep the conversation open-ended after sharing information, you can ask a follow-up question such as "Now that you know this information, what new ideas do you have about this artwork?" or "Does this information change the way you think about the artwork? If so, how?" This approach will promote synthesis and ensure that your conversation remains truly divergent.

When making curriculum connections, be mindful of reducing the work of art to being illustrative of a particular topic. Works of art are visual metaphors, and as such, they transcend the specific. By allowing the art inquiry discussion to remain open-ended while integrating information, it is possible to make strong connections to your curriculum while also encouraging innovative ways of thinking and honoring your students' unique ways of seeing.

Including Information in an Art Inquiry Discussion

The role of information in an art inquiry discussion is to give context to the work of art and to support student understanding as they form interpretations. I suggest selecting one to three key points of information related to the work of art and your goals/theme for the discussion. Brevity is key to keeping the conversation flowing, allowing students to process the information, and letting it inform their thinking.

There are many different types of information that can give context to a work of art; several are outlined below. Each of these information sources provide a different lens through which to understand a work of art. When selecting information to share with students, make sure that it aligns with your curriculum and is developmentally appropriate for your students.

Information Sources

- *Biographical information about the artist.* These stories can bring the art to life and facilitate personal connections. If you are sharing this information, make sure that it is truly relevant to your goals for the art inquiry lesson.
- *Artist quotes.* The words of the artist can provide insight into their work. Look for quotes that are directly related to the theme that your lesson supports.
- *Art historical interpretations or critical reviews, both positive and negative, about the work of art.* This information introduces new perspectives on the work of art for students to consider. By sharing differing scholarly interpretations with students, you can show them that there are many ways to interpret a work of art. Beware of introducing this type of information too early in the discussion, as it can inhibit students from forming their own interpretations. After sharing this information, ask students if they agree or disagree with the author's perspective, and why.
- *Sensory materials.* Materials that students experience through their senses can provide new insight into works of art. Marilyn Casey, an elementary art teacher, supported her students' investigation of Joan Mitchell's *Sunflowers* by giving them sunflowers in various stages of life and death. By touching and smelling the sunflowers, students were able to make visceral connections between the painting and its subject matter.
- *Information about the artist's process.* Art materials that relate to the work of art, and/or images of the art making process, can help students understand how the work of art was made. For example, showing students a video of Jackson Pollock painting will provide them with new insight into his work.
- *Contextual information related to function.* Most of the artworks in an encyclopedic museum were created for entirely different contexts. Understanding how artworks were originally used and displayed can deepen understanding and support interpretation. For example, know-

ing that a statue of the Buddha was originally in a temple where people came for contemplation and prayer will help students comprehend the purpose of the statue and the ideas it communicates.

- *Contextual information related to the time period/place/culture of the work of art.* This type of information is especially relevant if you are teaching about a specific time period and part of the world. This can take the form of primary source documents, images, historical information, and/or information about cultural beliefs and practices related to the work of art.
- *Information about the subject of a work of art.* For example, if the artwork is a portrait, biographical information about the subject may be compelling. If the work of art is a religious object, then information about the religious beliefs it embodies are essential for student understanding.
- *Sound/movement.* For works of art such as musical instruments or costumes, seeing and/or hearing them performed (through video or audio) will bring them to life.
- *The title of the work of art.* Even this small piece of information can provide new insight into the artwork.

Note

1. Below is the information that Nicole gave her students.

 Problem: American and British leaders and businessmen wanted to ship goods quickly and cheaply between the Atlantic and Pacific Oceans.

 Public Policy: Create a canal (artificial waterway connecting two bodies of water) to link the Atlantic and Pacific Oceans.

 Panama Canal Facts:

 - Construction of the Panama Canal began in 1903 and finished in 1914.
 - Rainforest had to be cut down to build the Panama Canal.
 - During construction, 27,000 workers died—mostly due to diseases such as yellow fever and malaria.
 - There were different pay rates for different people. White American and European workers were on the "gold roll." Afri-

can American, Chinese, and Indian workers were on the "silver roll." Segregation by race existed and working conditions were unsafe for most workers.

- Landslides and floods posed problems for the Panama Canal.
- Travel became faster. Before the Panama Canal, to ship goods from San Francisco, California, to New York City took more than sixty days and 13,000 miles of travel. After the opening of the Panama Canal, it took thirty days and 5,000 miles to reach New York.
- The Panama Canal helped make the United States a world power. The United States controlled the Panama Canal until 1999, when control was given to Panama.
- Since 1999, thousands of jobs were created and the Panama Canal Zone has become a popular spot for tourists, bringing in a lot of money for Panama.

Sources: Elizabeth Nix, "7 Fascinating Facts about the Panama Canal," History, August 15, 2014, http://www.history.com/news /7-fascinating-facts-about-the-panama-canal.

"Building the Panama Canal, 1903–1914," United States Department of State: Office of the Historian, Bureau of Public Affairs, accessed February 19, 2018, https://history.state.gov /milestones/1899-1913/panama-canal.

Anya van Wagtendonk, "How the Panama Canal Helped Make the U.S. a World Power," Public Broadcasting Service (PBS), August 15, 2014, http://www.pbs.org/newshour/updates/panama-canal -helped-make-u-s-world-power/.

7

Developing Personal Connections

Reflecting on her experience in the Astor program, one high school student highlighted the importance of nurturing personal connections with works of art: *With certain pieces of artwork, you can connect to your own life and the art piece becomes even more beautiful and understood.* When students feel that learning is relevant to their lives, they become more engaged and gain deeper understanding of content. To this end, art can be a bridge between academic content and students' lived experiences. By engaging students in art inquiry discussions that connect to your curriculum and to their own life experiences, you can leverage the power of art.

In this chapter, you will learn successful approaches for connecting art to students' lives and academic curriculum: first, by giving students choice in their learning; and second, by incorporating questions and activities that explicitly invite students to make personal connections to works of art.

In chapter 2, we spent some time with Darnese Olivieri's eleventh-grade students as they explored George Tooker's painting *Government Bureau* (photo 2.2). Throughout the year, the class continued to explore the question "What does it mean to be American?" through the lens of socioeconomic status, race, and gender as reflected in literature and in European and American art at The Met.

Toward the end of the year, Darnese's students expressed their desire for more freedom and choice during the museum experience. They also expressed their interest in looking at art that related to their Caribbean and Central American heritage. In response to this feedback, Darnese decided to let her students choose which gallery they would like to visit during their last museum visit of the year.

In the classroom, she projected images of different gallery spaces at The Met and invited her students to present arguments for which gallery the class should visit. After hearing several arguments, students voted. Overwhelmingly, the class chose The Met's Oceanic art galleries. The students were particularly drawn to the light-filled central gallery with its sweeping views of Central Park and large-scale wooden sculptures, displayed beneath a vibrantly patterned ceremonial ceiling from Papua New Guinea.

Their arguments for choosing this space related to its openness and light, as well as their interest in indigenous cultures from around the world. While their choice of gallery did not have a clear connection to their essential question, "What does it mean to be American?," Darnese knew that she wanted to focus on her students' personal identities as they related to the question.

Once her students had selected the gallery, Darnese developed a lesson that emphasized choice within a structure, with the goal of supporting students' ownership of their learning and autonomy within the museum space. Darnese wanted her students to feel a sense of belonging in the museum, with the long-term goal that they would utilize museums as a resource throughout their lives. During their previous museum visits, they had gained skills and confidence for talking about works of art, and this lesson gave them an opportunity to exercise those skills independently.

Darnese initiated the lesson by giving each student a set of prompts for looking that she had adapted from David Perkins's *The Intelligent Eye: Learning to Think by Looking at Art*.[1] The prompts encouraged deep looking from a variety of perspectives and gave directions for investigating a work of art over

an extended period of time by looking closely, writing, and sketching. Darnese invited her class to explore the gallery before settling on one work of art that personally resonated with them. She told students to choose wisely, because they were going to spend thirty minutes with their selected work of art.

Initially, her students stuck together, circumambulating the gallery in small groups.

Darnese was surprised by how quickly the groups dispersed as each student gravitated toward their own object. The prompt to find a work of art that resonated with them inspired personal reflection among highly social teenagers.

One student, Marco, was drawn to a tall, intricately carved ancestor figure in the corner of the gallery (photo 7.1). He remained deeply absorbed throughout the thirty-minute period, his gaze intent on the sculpture.

After thirty minutes of silent engagement with their chosen artwork, Darnese gathered the class together in the center of the gallery. She invited students to share their responses by asking, "Which artwork did you choose, and why? How did the art speak to you?"

Marco was the first to volunteer. "I chose this artwork because it reminded me of a father carrying a child on piggyback, like my father carried me when I was young. It made me remember those times and reflect on how different my life is now. I don't have anyone in my life who can protect me." Marco continued to speak about his experience as an undocumented young man who is the caretaker of his family and how his experience of becoming a man is colored by his status and the absence of his father.

While Marco spoke, many students in the class patted their hearts in a gesture that showed their solidarity. A few were moved to tears. Another student shared that she connected with Marco because she was also uncertain about her future, with the sense that she was on her own to navigate the complexities of adulthood and life in a new country. As more students shared, it became clear that they each had made very personal interpretations of the works of art that were rooted in their own experience.

Reflecting on the lesson, Darnese felt that "the art opened them up around their pain and struggle as humans and helped them connect to something larger than themselves. For them, art was connected to their humanity, part of this larger story. Connecting with works of art allowed them to unearth their own expressions of joy, pain, sorrow, defeat, insecurity, and love."[2]

Art inquiry creates opportunities for students to voice their own experiences, emotions, and concerns, and to have them validated. During art inquiry conversations, students learn from and about each other, building empathy and community. By allowing students' interests, concerns, and curiosity to drive the art inquiry experience, Darnese encouraged her students to bring their full selves to learning, to connect with each other and to the world.

There are two main components of Darnese's lesson that made it successful: student choice and the invitation to make personal connections with works of art. In this lesson, these two components were linked, as Darnese invited students to choose a work that personally resonated with them. Darnese's lesson placed her students' interests at the center of the learning experience.

The direction to "find a work of art that resonates with you" set the stage for students to make personal connections. In Darnese's lesson, students had choice in every aspect of the experience: from what gallery they would visit, to which artwork they would choose, to how they would interact with it. A very open-ended and student-directed lesson produced meaningful outcomes for her students.

Student Choice and Intrinsic Motivation

Choice leads to deeper engagement and helps students to become independent thinkers and learners. By encouraging students to select works of art that interest them, ask their own questions, and even facilitate their own discussions, you invite them to take ownership over their learning and make the most of their intrinsic curiosity and motivation.

Victoria Primiano, a second-grade teacher in Queens, brought her students on a class visit to The Met to learn about abstract art. After looking at one work of art together, she invited her students to walk around a small gallery full of abstract works and choose one that they liked best. Students sketched their chosen artwork and shared their ideas with nearby classmates.

One small group seated themselves beneath Alexander Calder's expansive mobile, *Red Gongs* (photo 7.2). Suspended from the ceiling, the mobile's leaf-like red and gold shapes are held aloft by graceful red wires. As students discussed the sculpture, they noticed that it was constantly in motion, responding to air currents in the gallery. Suddenly the mobile turned in such a way that the golden pieces caught the light, illuminating the children's upturned faces. Tiny balls at the end of the red wires hit the golden shapes, making a delicate ringing sound. They giggled with joy at these magical effects of light and sound. "I know why the artist made this sculpture," one of the students in the group exclaimed. "He made it so that we would feel happy!"

In this example, the students' intrinsic curiosity about the mobile led them from observation (*It's moving! It's golden.*), to evidence-based inference (*The air is making it move. The shapes are reflecting the light.*), to interpretation (*He made it so that we would feel happy.*) without the guidance of a teacher facilitator. Having the opportunity to select a work of art that captivated them allowed them to follow their natural curiosity and wonder to arrive at a thoughtful interpretation of the work of art.

As Victoria and Darnese's lessons demonstrate, inviting students to select works of art that interest them is an effective way to make learning engaging and relevant. By preselecting works of art for students to choose from, you can offer choice while making direct connections to your curriculum. For example, if your curriculum is focused on a specific culture, time period, or part of the world, you could select several works of art that relate to that topic and invite students to choose which ones they are most interested in. This could also be done in small groups based on students' interests.

Personal Experience Questions

A simple way to include students' personal experience in an art inquiry discussion is to include questions that explicitly invite personal connections. The purpose of these questions is to activate students' prior knowledge and experiences in order to draw out connections with the artwork and the curriculum.

Examples of questions that encourage personal connections include the following:

- Think of a time when you (experience related to the work of art—e.g., had a celebration with your family). How does this work of art connect to your experience? How is it different?
- What does this artwork remind you of?
- How does this artwork make you feel?
- What associations do you have with (subject of artwork)?
- How do you define (big idea embodied in the work of art—e.g., power)?
- What images are used to depict (big idea embodied in the work of art—e.g., protection) today?
- How would you update this work of art to reflect life today?

Incorporating student art making in response to works of art is a highly effective way to support personal connections. Examples of art-making ideas include the following:

- Create a sculpture that shows the roles and relationships within your family.
- Create your own abstracted design that represents the values and beliefs of your community.
- Create a work of art that illustrates an important lesson that you want to pass down to the next generation.

These art-making prompts take the big idea of a work of art and invite students to translate that idea in relation to their

own life experiences. Several art-making lessons are included in chapter 9, Art Inquiry Resources.

Student-Generated Questions

Another way to encourage students' inquisitiveness and independence is to create opportunities for them to spend time wondering about works of art and to formulate their own questions. You could try out this approach by asking each student to develop a question about an artwork and to pose it to the group to get their ideas. Below are some questions that you can use to encourage students to develop their own questions.

- What do you wonder about this artwork?
- What are you still curious about (at close of conversation)?
- What would you ask this artist / the subject of this artwork?

Lara Tyson, an art teacher in Harlem, incorporated student-generated questions during an art inquiry discussion of Jacques Louis David's *The Death of Socrates* (photo 3.1). Her goal was to develop her fifth-grade students' curiosity about the painting and to build upon their observations.

She began by inviting students to look closely at the painting and come up with several questions based on what they saw. Then she told the class that each student would have the opportunity to ask their question, but that there could be no repetition: if another student asked the same question, they would have to think of a different one to ask. After giving the class two minutes to think about and write down their questions about the painting, she asked each student to select one to share. Her students' questions included these:

Student: What's happening?

S: Why is the guy the only one on the bed and everyone else is standing?

S: Why is there a shadow?

S: Where are they?

S: Why are they all surrounding him?

S: What happened to the guy with his hands on his face?

S: Why don't they have shoes?

S: Are they in pain?

S: What's the time period?

S: Where are all the people going in the back?

S: Why is that guy sleeping?

S: Why do they all look so dramatic?

S: Why does that one guy look powerful and the rest of them look small?

S: Why do they look upset? What happened?

S: What are they doing for the guy in the red?

S: Why is only one person wearing shoes?

S: Who are these people?

S: Why is there no light and why are there no doors?

Lara used her students' questions to segue from the observation to the inference phase of the conversation by inviting students to respond to any of the questions their classmates posed. By following students' own curiosities about the painting, Lara ensured that all of her students remained deeply engaged.

Once students have some comfort developing and posing their own questions, they can take on the role of facilitator and lead inquiry discussions with their peers. A simple way to prepare students to lead inquiry experiences is to invite them to choose a work of art, observe it closely, and develop two or three questions to start a discussion with their classmates. Once they have created their questions, students can take turns facilitating art inquiry discussions in small groups or with the whole class.

Brian Tauzel teaches American history at an international high school for recent immigrants. As immigrants, and as students from diverse ethnic, cultural, and religious backgrounds,

many of his students were threatened by the intolerance that surfaced during the 2016 presidential campaign. Responding to his students' concerns, Brian focused a lesson at the museum on using art to counter Islamophobia.

For their final trip to the museum, Brian invited several students from his twelfth-grade class who identify as practicing Muslims to select works of art in The Met's Islamic art galleries and worked with them to prepare inquiry-based experiences that would help their classmates see the complexity of beliefs, values, and teachings of Islam. During the museum visit, these students became teachers, sharing their expertise and personal experiences while inviting their classmates to ask questions and make connections to their own religious practices. This experience fostered cross-cultural understanding among a diverse group of students, while deepening their understanding of current political issues in the United States.

Art inquiry is a powerful method of bridging students' lives and academic content to deepen learning. When you engage students in conversations about works of art that connect to their life experiences and to the curriculum, learning becomes relevant and meaningful.

Notes

1. David Perkins, *The Intelligent Eye: Learning to Think by Looking at Art* (Santa Monica, CA: Getty Center for Education in the Arts, 1994).
2. Darnese Olivieri, conversation with author, October 6, 2017.

8

Planning and Facilitating Art Inquiry Experiences

Artwork Selection

Now that you have a solid foundation in the Pyramid of Inquiry, you are ready to begin planning an art inquiry lesson. The first step is selecting a work of art to teach from. When selecting an artwork, there are three main questions to consider:

- **Does this artwork spark my curiosity?** Look for works of art that capture your interest. Your curiosity will set the tone for your students' investigation. If you are excited to explore a work of art, your students will be engaged. Select works of art that are open to interpretation and can be read in many different ways. Artworks that are rich in ambiguity lead to the most lively discussions.
- **How does this artwork relate to my students' lives?** The artwork you choose will be a bridge between your curriculum and the lives and interests of your students. As you look at works of art, think about how they might relate to your students' experiences. Will your students see themselves reflected in the work of art? Does it connect to their identities in some way? Does it relate to current events and social issues that students care about? What universal ideas (love, friendship, struggle) are embodied

in the artwork? As you look at works of art, ask yourself, "What might my students think about this work of art? What might surprise or intrigue them about it?" Try to see works of art through your students' eyes and imagine what might incite their curiosity.

- **How does this artwork relate to our curriculum?** Because art represents the full spectrum of human experience, it can be an effective tool for teaching any subject. Consider using art inquiry as a way to enliven a topic that your students particularly struggle with, or that you feel less than inspired to teach. When selecting a work of art that connects to your curriculum, it can be helpful to think in terms of themes or essential questions, rather than to look for artworks that illustrate a particular time or place. In the lesson described in the introduction, an eighth-grade English language arts teacher named Laura Smith used Artemisia Gentileschi's painting *Esther before Ahasuerus* (photo 0.1) to connect with her class study of Shakespeare's *Romeo and Juliet*. Her essential question was *Does fate have more control over our lives than the choices we make?* When selecting a work of art to teach from, Laura looked for connections to her essential question, rather than artworks from Shakespeare's time or depictions of the play. Gentileschi's painting was a good fit because of its drama, tension, and powerful narrative. While the painting did not have a direct connection to *Romeo and Juliet*, it served as a compelling image that connected to Laura's essential question and illuminated the themes of the play.

Selecting an Artwork: Practical Considerations

Depending on whether you are teaching in the museum or classroom, there are several logistical considerations to keep in mind when selecting an artwork to teach from.

If you are planning to teach an art inquiry lesson in a museum, visit the museum on your own before the class trip to

see the works of art in person. As you view potential teaching objects, keep in mind the following:

- The size of the artwork: Will everyone be able to see it at once?
- The space surrounding the artwork: Is there room for the whole class to sit while viewing?
- Distractions: Is the artwork in a busy gallery? Are there other artworks or sounds in this space that might distract the group?

If you are planning to teach the art inquiry lesson in the classroom, the best place to search for artworks is on museum websites. (Links to museum websites with high-quality images available to download are available in chapter 9: Art Inquiry Resources.)

As you search for works of art, consider:

- Is there a high-quality reproduction available?
- If it is a large-scale artwork, does the image communicate its size?
- If it is a three-dimensional artwork, are images of more than one side available?

Art Inquiry Preparation

Once you have selected the works of art you plan to teach from, it is important to get to know them as much as possible. Before you begin to develop an inquiry plan that will engage your students in investigating the work of art, investigate the work of art on your own by following these steps:

Spend time with the artwork. This is essential. Viewing the artwork in person is preferable, but if this is not available to you, seek out a high-quality image. Look closely at the artwork from as many angles as possible: up close, from a distance, and in the round. Sketch the artwork from observation and label your drawing with descriptive details. Develop your curiosity about

the artwork by spending some time wondering about it and writing a list of your questions.

Buy a postcard of the artwork or print a color image and put it somewhere in your home where you will see it every day. Initiate informal conversations with your family and friends by asking them to share their impressions. After a week of living with your artwork, you may see it very differently than you did at first.

This experience will prepare you to lead rich discussions with your students about the work of art. However, once you bring your students into conversation with the work of art, you must be prepared to let go of your own interpretations. They may see it in completely different ways than you did, and that is as it should be. In fact, that is the beauty of this approach!

Research the object. What contextual information can you find that will help you gain a deeper understanding and see the artwork in new ways? If the artwork is in a museum collection, begin your research on their website. Museum websites will provide basic information about the work of art and often link to scholarly essays that will provide deeper insight. You may not share all of the information you learn with your students, but it is essential to develop your own knowledge about the work of art through research, as you would with any content you are teaching.

Composing an Art Inquiry Lesson

When creating an art inquiry lesson, use the following sequence:

- 1–2 Observation questions (or activities)
- 1–2 Evidence-based inference questions (or activities)
- 1–2 Pieces of information about the work of art
- 1 interpretation question

An inquiry plan template is provided in chapter 9: Art Inquiry Resources. As you gain experience with the method, feel free to experiment and play with the format. The Pyramid of Inquiry is not prescriptive; it provides an open-ended frame-

work that you can adapt for your specific curriculum and your students' learning needs.

Creating Divergent Questions

Divergent, or open-ended, questions inspire critical and creative thinking and invite students to share their unique perspectives in a nonthreatening, supportive way. The following criteria for effective questions were developed by museum educators from The Metropolitan Museum of Art, MoMA, and the Guggenheim Museum during Connecting Collections, a recurring weeklong summer institute for teachers.

Quality Questions:

- Are open-ended and invite multiple responses
 - As you develop questions, put them to the test by asking yourself to think of multiple responses to each question. If you can come up with at least three possible responses, the question is divergent. If you are expecting one "correct" answer, the question is convergent. Try rephrasing the question to make it open-ended. The purpose of asking divergent questions is to encourage and validate divergent ways of thinking. How can you inspire students to approach works of art in imaginative ways?

- Encourage close looking
 - Make sure that your questions require close investigation of the work of art, and ask students to provide visual evidence for their ideas. This will ensure that the conversation remains grounded in the work of art.

- Support your theme and lesson goals.
 - There are endless questions you could ask students about a work of art, but your goal is to make connections to your curriculum. Include questions that align

with your lesson theme and goals, and eliminate those that do not.

- Are sequenced from observation to interpretation
 - ◦ Begin with observation questions, follow with evidence-based inference questions, and conclude with an interpretation question.

Multimodal Activities

Multimodal activities invite students to respond to works of art in a variety of ways beyond discussion. Movement, dramatic play, writing, art making, and sensory activities give students opportunities to demonstrate different ways of knowing. By including these approaches in an art inquiry lesson, you can deepen engagement with works of art and support the diverse learning needs of your students. Aim to include at least one multimodal strategy in each art inquiry discussion. You can incorporate multimodal strategies during the observation, evidence-based inference, or interpretation phase of the discussion.

Facilitation: Setting the Stage for a Productive Art Inquiry Discussion

Engaging in art inquiry with students is a powerful act. You are inviting your students to share their thoughts and perspectives in a supportive, collaborative environment, and you are *listening* to what they have to say. As a teacher, letting go of control and allowing your students ideas to drive the conversation can be scary, but it is ultimately rewarding. Art inquiry is an opportunity to learn from and about your students, while nurturing their academic and social development.

Art inquiry discussions foster collaborative meaning making. As students investigate works of art together, they contribute their individual perspectives, listen, and respond to their classmates' ideas. This work requires a respectful classroom community. Before beginning an art inquiry discussion, it is

necessary to agree on some group norms to ensure that all voices are heard and respected.

These norms should include the following:

- Mutual respect—respect others' ideas and opinions, even if they differ from your own.
- Listen to each other—one speaker at a time.
- There are no right or wrong answers.
- Everyone is encouraged to share.
- Try to see through each other's eyes.

You can introduce art inquiry to students in the following way:

Today we are going to spend some time looking at and discussing a work of art together. When we look at art, there are no right or wrong answers. I'm going to ask you to look closely, share your ideas about what you see, and listen respectfully to others' ideas. Everyone's ideas are important. We all see things differently and when we look at art, we can learn to see through each other's eyes.

At first, students might be confused by your insistence that there are no right or wrong answers: the idea likely runs counter to their previous academic experiences. By consistently asking divergent questions and listening to your students' ideas, they will develop trust that you are actually asking them what they think, rather than expecting a predetermined answer.

Supporting Student Participation

During art inquiry discussions, students need time to think. Close observation and rigorous thinking take time, and rushing from question to question can inhibit students, limiting the discussion. In order support students' thinking process, use wait time after asking each question. Don't be afraid of silence; lean into it. Take the time to look at the work of art yourself and let students' ideas synthesize.

To encourage participation from all students, provide opportunities for turn and talk, small group discussion, and individual reflection. Varying the ways that students are invited to contribute to the discussion will ensure that all students have an opportunity to be heard, even if they are uncomfortable sharing their ideas with the whole class.

Another way to encourage participation and hear from diverse viewpoints is to play a game such as "Round Robin" or "Popcorn Share," where each student identifies something that they see in the artwork or a word that they associate with it, and everyone in the group takes turns quickly sharing their ideas. This provides every student with an opportunity to contribute to the discussion in an unintimidating way.

Supporting Language and Vocabulary Development

Art inquiry discussions are opportunities to model good listening for your students. One way to show students that you are listening closely is by paraphrasing their ideas. This technique gives the class another opportunity to hear the idea that was expressed, while the student that shared gets to hear their idea repeated and validated by their teacher.

As students share their ideas, encourage them to describe what they see in greater detail, inserting rich vocabulary to support their language skills. For example, in response to *"What do you notice?"* a student might respond, *"A dog."* Rather than move to the next student, the teacher could respond: *"You notice a dog in the painting. Where do you see the dog? In the background, foreground, or middle ground of the painting?"* As you say those vocabulary words, you can point out those areas of the painting. By doing so, you are teaching vocabulary in context, honoring students' ideas, and drawing their attention to different areas of the artwork.

Another strategy for developing vocabulary is to provide students with vocabulary lists that have descriptive words related to the artwork they are looking at. Students can refer to these lists to describe what they see. This can be especially helpful for English language learners.

Finally, art inquiry discussions are great opportunities to introduce accountable talk so that students have the language to respond to each other, share ideas, and respectfully disagree. These sentence starters support language development and encourage the conversation to take place among students in the class, rather than just between students and teacher. Examples of accountable talk sentence starters that are useful in an art inquiry discussion include:

- I agree with your point that _____, but I wonder . . .
- To build on what _____ said . . .
- I'm not sure I agree that _____ because . . .
- At first I thought _____, but now I have evidence that _____, so I'm wondering . . .
- I see a connection between what _____ said and what _____ said because . . .

Your first inquiry experience may not be long, especially with young students. Sometimes it's best to cut off the conversation and save it for another day, to keep students curious rather than belabor the process. Over time, students will build their capacity to engage in extended conversations about works of art.

Why Take Students to Museums?

In her opening remarks at the new Whitney Museum of American Art in 2015, Michelle Obama made a moving statement in support of engaging young people in museums:

> You see, there are so many kids in this country who look at places like museums and concert halls and other cultural centers and they think to themselves, well, that's not a place for me, for someone who looks like me, for someone who comes from my neighborhood.
> In fact, I guarantee you that right now, there are kids living less than a mile from here who would never in a million years dream that they would be welcome in this museum. And

growing up on the South Side of Chicago, I was one of those kids myself. So I know that feeling of not belonging in a place like this. And today, as First Lady, I know how that feeling limits the horizons of far too many of our young people.[1]

As the First Lady describes, many young people do not feel that art institutions are spaces where they belong. Art museums can be formidable spaces, and hold historic connections to colonialism, imperialism, and racism. Taking students to museums and engaging them in conversations that validate their voices and opinions is a powerful way to give them access to places that they may feel are off limits to them because of their race, socioeconomic status, or other factors.

During the Astor Educator Initiative, we witnessed students becoming more self-confident and comfortable at The Metropolitan Museum of Art as the year went on. This shift was also reflected in an attitude survey that high school students completed before and after the program. We learned that the experiences that students had engaging in art inquiry in the museum space expanded their confidence, their attitudes about art, and their views of themselves as learners. Positive experiences in museums can develop a sense of belonging and entitlement in cultural institutions that students will carry with them throughout their lives.

In the next chapter, you will find resources for implementing the Pyramid of Inquiry into your teaching practice, including lesson plans, art-making activities, and a wealth of questions and multimodal activities.

Note

1. The White House, Office of the First Lady, "Remarks by the First Lady at Opening of the Whitney Museum," Obama White House, April 30, 2015, https://obamawhitehouse.archives.gov/the-press-office/2015/04/30/remarks-first-lady-opening-whitney-museum.

9

Art Inquiry Resources

In this chapter, you will find lesson plans and resources to support inquiry-based teaching with works of art in your own practice.

Below are examples of questions and activities that elicit observation, inference, evidence, and interpretation for K–12 students. You can select from these ideas to curate art inquiry plans that align with your curriculum goals and your students' learning needs.

Observation: What You See

Observation Questions
- What do you notice?
- What do you notice about (focus on an aspect of the artwork)?
- What do you see?
- Describe (a particular aspect of the artwork).
- What stands out to you?
- What captures your attention in this work of art?
- Compare/contrast.
- Create a list of adjectives and nouns capturing what you see.
- What curious details can you find in this work of art?

Observation Activities
- Eye Spy: Find an interesting detail in the work of art and describe it to classmates.
- Zoom In: Use a viewfinder to find one detail in the work of art you would like to explore further. Optional: Sketch the detail you selected.
- Labeled Sketch: Closely observe a work of art and sketch what you see. As you draw, write notes along the perimeter to remind you of key features. Use lines to connect your notes with details in the drawing.
- Gesture Drawings: Make quick (30 second–2 minute) drawings of a figure that captures the essential forms and weight distribution of the body.
- Movement Wave: Pick a shape or line in the artwork and generate a word and corresponding movement to describe it. Take turns sharing your word/movements with the group and discussing which part of the painting inspired it and why.
- Soundscape: Imagine that you are inside the painting. What sounds might you hear? As a group, perform your sounds together.
- Texture Bags: Gather materials with textures that relate to the object being viewed and place them in a paper bag. With a partner, take turns placing your hand inside the bag (no peeking!) and describing the texture you feel. Work together to locate a part of the artwork that might feel that way if you could touch it.
- Use your sense of touch to gather information about a work of art by handling samples of the materials used to create it.

Evidence-Based Inference: What You Think about What You See

Evidence-Based Inference Questions
- What do you think is happening in this work of art?
- What do you think is the story in this work of art?
- What's going on in this artwork?
- How would you describe the mood of this artwork?
- How do you think this artwork was made?
- What word comes to mind when you look at the artwork?
- How might this artwork have been used?
- What can you infer about the relationship between the figures in this artwork?
- What symbols can you identify in this artwork? What might they represent?
- What do you think will happen next?
- What do you think the artist chose to emphasize?
- Why do you think the artist chose to (identify an artistic choice in the artwork)?

Always prompt students to provide visual evidence for their inferences by asking a follow up question such as "What do you see that makes you say that?"

Evidence-Based Inference Activities
- Recreate the pose of a figure in a work of art and consider what the person might be thinking, doing, or feeling.
- Imagine that you are creating this painting. How would you move your body to replicate the artist's brushstrokes?
- Create speech bubbles for the figures in a work of art and write down what you think they might be thinking/saying.
- Imagine what may have happened just before the moment depicted in a work of art and/or what might happen next. Sketch and/or write down your ideas.
- Write down one thing you find surprising, interesting, and/or troubling about the artwork.
- Write an account of what is going on in a narrative painting from the point of view of a figure, an animal, or an object in the work.
- Imagine that you have stepped into this work of art. What do you smell? Hear? Touch? Taste? Create a poem that describes the experience of being inside the artwork.

Interpretation: What It's All about (The Big Idea)

Interpretation Questions
For students of all ages/abilities:
- What do you think is the moral of this story?
- What do you think is the main idea of this artwork?
- What do you think this artwork is about?
- What are some emotion words that describe how you feel when you look at this artwork?
- Why do you think this artwork is (identify an artistic choice, such as scale, materials, colors)?

For older/advanced students:
- What do you think is the message of this artwork?
- Why do you think this artwork was made?
- What does this artwork suggest to you about (life, love, relationships)?
- What do you think the artist is trying to show/convey with this artwork?
- What big ideas/themes does this artwork bring up for you?
- What might be the purpose of this work of art?
- (After giving information) How does this information change or confirm your ideas about this artwork?
- How do you think the artist felt about (subject of artwork)?
- What might this painting communicate about life in (location/setting/time period)?
- What might this artwork tell us about the values, beliefs, or cultural practices of the society in which it was made?
- What do you think this artwork can tell us about the artist who made it?

Interpretation Activities:

For students of all ages/abilities:

- Create a new title for this artwork that communicates the big idea.
- Create your own work of art that responds to / reinterprets the big ideas embodied in the artwork.

For older/advanced students:

- Debate: Develop an interpretation of the artwork and defend it. Take turns presenting your argument and listening to classmates' perspectives.
- Write a journal entry from the artist's perspective. Imagine the artist's process and their ideas/feelings about the artwork as it was being created.
- Incorporate texts that relate to the artist/artwork: artist quotes/video, critical reviews of the artwork, historical documents, and so on. How does reading the text illuminate the artwork in new ways?

Personal Connection Questions

Activate Students' Prior Knowledge and Experiences in Order to Make Connections between the Artwork and Their Own Lives.

Questions

- What does this artwork remind you of?
- How does this artwork make you feel?
- What associations do you have with (subject of artwork)?
- How do you define (big idea embodied in the work of art, e.g., power)?
- What images are used to depict (big idea embodied in the work of art, e.g., protection) today?
- Think of a time when you (experience related to the work of art, e.g., had a celebration with your family). How does this work of art relate to your experience? How is it different?

Art-Making Activities

- How would you update this work of art to reflect life today?
 Create your own artwork on a similar theme. For example:
 - Create a sculpture that shows the roles and relationships within your family.
 - Create your own design that represents the values and beliefs of your community.
 - Create a vase that illustrates an important lesson that you want to pass down to the next generation.
 - Decorate your own sarcophagus: How do you want to be remembered? What images will you include for the world to remember you by?

Student-Generated Questions:
Encourage Students' Curiosity and Incite Student-Led Discussion.

Questions
- What do you wonder about this artwork?
- What are you still curious about (at close of conversation)?
- What would you ask this artist / the subject of this artwork?

Activities
- I See/I Think/I Wonder[1]
- I Wonder/Maybe: Each person develops a question about the artwork and poses it to the group, who responds with their ideas.
- Socratic Seminar:[2] Students spend time looking closely and developing questions about a work of art. Students take turns posing questions to each other and responding to the work of art, facilitating the discussion among themselves while the teacher observes and provides support if necessary.

1. Patricia Palmer, David Perkins, Ron Ritchhart, and Shari Tishman, "See Think Wonder: A Routine for Exploring Works of Art and Other Interesting Things," Harvard Project Zero: Visible Thinking Routines, accessed February 19, 2018, http://www.visiblethinkingpz .org/VisibleThinking_html_files/03_ThinkingRoutines/03c_Core_routines/SeeThink Wonder/SeeThinkWonder_Routine.html.

2. "Socratic Seminar," Facing History and Ourselves, accessed February 19, 2018, https:// www.facinghistory.org/resource-library/teaching-strategies/socratic-seminar.

You can use this template to develop art inquiry lesson plans using the Pyramid of Inquiry.

Art Inquiry Lesson Plan Template

Step 1: Select a work of art that

1. connects to your curriculum/learning goals.
2. connects to your students' lives.

Step 2: Using the template below, develop a sequence of questions that will engage your students with the work of art. Please refer to the Pyramid of Inquiry and the four points for quality questions as you develop your plan.

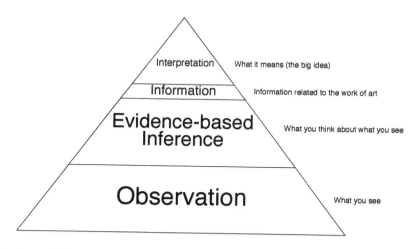

The Pyramid of Inquiry

Quality Questions

- Are open-ended and invite multiple responses
- Encourage close looking
- Support your theme and lesson goals
- Are sequenced from observation to interpretation.

Lesson Title

Educator:

Subject Area:

Class information:

Goal(s):

Theme/Essential Question:

Artwork:

Open-ended questions related to the artwork:

Observation questions (1–2):

-

-

Inference/Evidence questions (1–2):

-

-

Information:

-

Interpretation question (1):

-

Classroom-based lessons: The following lesson plans were designed as an introduction to art and art museums for K–12 students.

Introduction to Art and Museum Collections

This lesson is an introduction to engaging with works of art and museum collections. It was designed for Kindergarten–third grade students but can be adapted for a variety of ages and learning needs. The goals of this lesson are to introduce strategies for looking at and discussing works of art and to encourage students to make personal connections with works of art. Students will observe works of art closely through verbal description and observational sketching, make evidence-based inferences by

sorting and grouping works of art, and interpret works of art by creating their own thematic art collection.

Materials

For this lesson, you will need at least five three-dimensional artworks. The artworks should be diverse in material, texture, and subject matter. For example, you could include a mask, a textile, a small painting on canvas, a carved sculpture, and a ceramic artwork.

To support students' vocabulary acquisition, create a word wall of art terms for shape, color, line, texture, and material, and encourage students to refer to the word wall as they describe works of art.

Games

Game 1: Touch and Describe

Divide students into small groups, and give each group an artwork. Invite students to take turns touching and describing the artwork to each other. Students can also sketch the artworks from observation. Rotate the artworks so that each group gets a chance to touch and describe at least two.

Game 2: Eye Spy

Gather the class together and place the artworks where every student can see them. Tell students that they are going to play a game of Eye Spy. Model the game by choosing one of the artworks (without telling students which one you chose) and describing it using art vocabulary. For example: *I spy an artwork that is round, blue, feels bumpy, and has curved lines.* Once you have described the artwork, ask students to identify which one they think you were describing. Let students have several turns describing and identifying the different artworks.

Game 3: Curate a Collection

Explain to students that museums have collections of artworks, and that curators are people who work at a museum who group the artworks together according to their similarities. Ask students, do you have a collection at home? What do you like to collect, and why? Tell students that they will be curators and create their own art collection.

As a warm up, look at the artworks together and encourage students to find similarities among them. As students "curate" the objects, you can group them together. Example questions to help students find similarities among objects include the following:

- Can anyone find artworks that are round?
- Can anyone find artworks that feel smooth?
- Can anyone find artworks that are shiny?
- Can anyone find artworks that depict animals?
- Can anyone find artworks that make you feel happy?
- Can anyone find artworks that are similar in a different way?

Art-Making Activity: Build Your Own Art Collection!

Art Materials: Long strips of black paper, images of diverse works of art, glue sticks

Invite students to create their own art collection based on their own interests and preferences. Distribute strips of paper and images of artworks for students to choose from. Encourage students to select five to six images that catch their attention and to sort their images according to their similarities.

Once students have collected and sorted their images, they can glue them to their paper and give their work a title. Finally, students can write the title of their collection on an index card and display it alongside their work. Have a gallery walk, where students view their classmates' collections and ask questions about the choices they made.

K–5 Art-Making Lesson: Museum of Us

Art Materials: self-drying clay (Crayola Model Magic is a non-messy alternative)

In this lesson, students will engage in close observation to create a sculpture of an object that holds special significance to them. After creating their sculptures, they will curate a class museum by finding common threads among their work.

The goals of this lesson are to foster close observation through sketching and recreating an object, to make connections interpersonally with classmates and between works of art, and to infer thematic connections among works of art and interpret the "big idea" of a museum exhibition.

Ask students to identify an object from their life that has special meaning. It could be something they use every day, something that marks an important event in their life, something that is part of a family or community ritual, and so on. Have students bring this object into the classroom from home.

In the classroom, students will sketch their object from observation. Depending on writing fluency, students can write three words to describe their object or a few sentences describing the object and why it's important to them.

Experiment with the clay. Give students time to play with the material and discover its possibilities and limitations. Encourage students to roll, pinch, stretch, and build with the material. As students experiment, encourage them to share their discoveries with each other.

Once students have gained familiarity with the clay, invite them to sculpt their special object. They can observe their object while reproducing it in clay, or use their sketch as a reference. You may choose to have students paint their objects once the clay is dry. Note: this project can take place over several class periods.

When the sculptures are complete, invite each student to share their object and why it is important to them. As their peers share, ask students to look and listen closely and think about how their classmates' objects are similar to or different from their own.

Explain the idea of an art exhibition and how curators select and display artworks that share a common theme. Ask students

to form small groups by finding classmates with objects that are similar to their own and grouping their objects together according to a theme. Once the students have formed their groups, give each group a stack of postcards of works of art and invite them to select three or four of works of art to be a part of their exhibition.

Next, ask students to create a title for their gallery and to write museum labels for their objects based on the writing they did with their initial sketch. Once the galleries are complete, the class can have a gallery walk, with each group presenting their galleries to the class, providing visual evidence to support their theme.

After hearing from each group, reflect with students: what can this class museum tell people about what is important to the students in this class?

K–5 Art-Making Lesson: Objects of Power and Adornment

The goals of the lesson are for students to interpret and create works of art, making connections between their own lives and works of art across time and place.

Introduce the lesson by explaining to students that they will be looking closely at three wearable works of art: one from Ancient Egypt (photo 9.1), one from sixteenth-century Nigeria (photo 0.2), and one from Peru (photo 9.2). Tell students that they will be making their own wearable work of art after looking closely together, and invite them to think about what they might take from each object as inspiration to make their own.

Show students images of all three artworks and invite them to take a moment to look at each of them. After viewing the objects, ask students to choose their favorite, and to create a labeled sketch. After sketching the artwork, younger students can label the parts of the object that stand out to them. Older students can draw arrows to anything on the artwork that might be a symbol and label their sketch with what they think those symbols might represent. As a class, discuss each object together using the following inquiry plans.

Artwork #1: *Pectoral and Necklace of Sithathoryunet with the Name of Senwosret II* (photo 9.1)

Observation Question

- What do you notice? *As students share their observations, encourage them to make inferences by asking, "What might that tell you?"*

Information

- This necklace was worn by an Egyptian princess named Princess Sithathoryunet. The figure of a man on the necklace is her father, King Khakheperre (Senwosret II). The hieroglyphs read, "The god of the rising sun grants life and dominion over all that the sun encircles for one million one hundred thousand years [i.e., eternity] to King Khakheperre [Senwosret II]."

Interpretation Question

- Why do you think the princess would wear this necklace?

Artwork #2: *Queen Mother Pendant Mask: Iyoba* (photo 0.2)

Observation Question

- What do you notice?

Evidence-Based Inference Question

- What character traits would you use to describe this person?

Information

- This object was worn by the king, or Oba, of Benin in Nigeria on special occasions. It represents his mother, Queen Idia.

Interpretation Question

- Why do you think the king would want to wear this pendant?

Artwork # 3: *Funerary Mask* (photo 9.2)

Observation Question

- What do you notice? *As students share their observations, encourage them to make inferences by asking, "What might that tell you?"*

Information

- This mask was worn by a Peruvian king after he died. It represents the face of a god called the Sicán Deity, who had the power to control all of the forces in the universe.

Interpretation Question

- Why do you think the king would want to wear this mask after he died?

Art-Making Activity

Art Materials: large shapes cut from tagboard, string, hole punches, oil pastels, popsicle sticks / wooden clay tools / toothpicks (for sgraffito), images of the three artworks.

If you were to create a pendant that would make you feel powerful, what images would you include on it? Think about the people and things in your life that make you feel strong, happy, safe, and loved. Pick three of these ideas to include on your pendant.

Art-Making Process

- Model oil pastel techniques for students: blending colors, layering dark colors over light and scratching with a tool

to reveal the color underneath (sgraffito). Encourage students to draw an outline in a light color, fill in large areas with color, and use black or dark colors last.
- Students select a shape for their pendant (older students can cut their own, younger students can choose from pre-cut shapes).
- Students will use oil pastels to fill their pendant with imagery.
- Using a string and hole punch, make the pendants into necklaces.
- Once students complete their artwork, they can wear it and share their ideas with each other.

K–12 Art Inquiry Lesson: Token Response

Materials:

5–6 color images of diverse works of art
Emoji cards that represent love, hate, makes me think, and take it home.

Token Response is a fun game to play with students of all ages to initiate lively discussion to encourage students to express their own opinions about works of art. This game can often turn into a heated debate in which students create evidence-based arguments for which artwork they think is "the best" or "the worst."

1. Display the artworks in the classroom (or, if you are facilitating this game at a museum, choose a gallery).

2. Give each student a set of emoji cards (one emoji for each of the four categories: love, hate, makes me think, and take it home).

3. Invite students to look carefully around the classroom/ gallery at each of the artworks. Encourage silent looking so that students have the opportunity to form their own opinions.

4. Tell students that they must decide which artwork they love the most, which artwork they hate, which artwork makes them think, and which artwork they want to take home with them. Once they have decided, they will place the corresponding emoji cards beneath the artwork they chose for each category. Each student can only choose one artwork per emoji. Ask students to briefly explain their choices in writing.

5. As a class, visit each work of art and discuss why each person made their decisions. Encourage students to listen to each other's perspectives and agree or disagree respectfully.

6. Spend some time sharing information about each artwork based on students' curiosity.

7. Ask students if their initial opinions of any of the artworks changed after hearing from their classmates and learning some background information. Continue the discussion by having students explain how their thinking changed.

High School Lesson: Curate a Show

If I had to be defined at this point I'll take the title of an inventor or maybe curator.

—Kanye West[1]

If your students care about Kanye West, share this quote with them and ask what they think a curator is. Tell students that in a museum, curators decide which artworks a museum displays

and how they are displayed. Curators purchase works of art, research works of art, and create exhibitions by choosing objects that relate to one another through a common theme.

Tell students that they are going to have the opportunity to try out the role of curator and to select images based on a theme that interests them. Introduce students to different ways of sorting and combining works of art: by subject matter, type of art (sculpture, painting, installation, etc.), genre (landscape, portrait, still life, etc.), material (wood, clay, glass, etc.), elements of art (line, shape, color, texture), style (abstract, realistic, etc.), mood/emotion.

Display a wide variety of art images and invite students to select between five and seven for their exhibition. As students make their selections, encourage them to go beyond their initial ideas and think creatively about connections between the images. Once the theme of their exhibition has been decided, students can connect all the works of art to create a narrative thread or create subthemes within their exhibition.

Finally, ask students to give their exhibition a title and present it to the class. Students should provide visual evidence to support their selections. They should also make the case for why their exhibition is important and should be displayed in an art museum.

High School Art-Making Lesson: Artists' Choices

In this lesson, students will examine how contemporary artists reinterpret works of art from the past in order to create new meanings. Through analyzing the work of Mickalene Thomas (photo 9.3) and Edouard Manet (photo 9.4) and creating their own collage, students will explore how artists' choices convey a point of view.

Observation Question: *Le Déjeuner Sur L'herbe: Les Trois Femmes Noires* (photo 9.3)

- What parts of this artwork capture your attention?

Evidence-Based Inference Question

- The artist, Mickalene Thomas, took inspiration for this artwork from a nineteenth-century painting by Edouard Manet. With a partner, compare and contrast Thomas's painting with Manet's *Le Déjeuner sur l'herbe* (photo 9.4).

Interpretation Question

- How and why do you think Thomas transformed Manet's painting?

Art-Making Activity

After close investigation and discussion of the works of art above, invite students to select three images from a variety of works of art and images of contemporary events. Encourage students to experiment with different approaches to cutting, layering, and arranging these images in order to convey their own message.

When selecting images of current events, think about issues that are compelling to your students. When I taught this lesson, in the winter of 2016, Black Lives Matter, the 2016 presidential election, and Beyoncé's Super Bowl performance that year were topics that students felt passionately about. I collected and printed related images from the news, and displayed them alongside images from The Metropolitan Museum for students to choose from. I encouraged students to choose a mix of art and news images, with the idea that they would "remix" them to express their ideas. Students were deeply engaged by this opportunity to express their ideas about current events and found exciting ways to juxtapose the images to create new meanings.

Display and share the completed artworks. Reflect with students:

- What viewpoint or perspective does your collage express? How did your arrangement or composition help show this?

Art Inquiry Lesson Plans

The following lesson plans were developed by K–12 teachers in the Astor Educator program at The Metropolitan Museum of Art between 2014 and 2017. They were taught during visits to the museum but can easily be adapted for teaching in the classroom.

Lesson Title: Exploring Color and Emotion

Subject Areas: English Language Arts, Visual Arts
Grade: Kindergarten
Author: Valerie Patterson
Artwork: Mark Rothko, *No. 16* (photo 5.1)
Goals: Students will be able to:

- Understand that colors can be used to create emotions.
- Describe a personal, emotional response to the colors in a Rothko multiform painting.

Question Sequence

Observation Questions

- Take a few moments to look closely. When you're done, have a conversation with a partner about some of the things you noticed.
- What do you notice about the shapes and lines in the painting?
- How would you describe the colors the artist used?

Evidence-based Inference Question

- How do you think he created these colors?

Information

- Rothko once said, "If you are only moved by color relationships, you are missing the point. I am interested in expressing the big emotions—tragedy, ecstasy, doom."

Interpretation Questions

- Based on the colors in the painting, what are some "big emotion" words you would use to describe a feeling you experience when you look at the paintings? Explain your thinking.
- Why do you think Rothko made his paintings so large?

Lesson Title: *The Little Fourteen-Year-Old Dancer*

Educator: Fèlix Portela
Subject Area: Visual Arts
Class information: Grade 2
Goals: Students will be able to:

- Understand how a portrait can convey multiple aspects of a person.

Theme: Portraiture
Artwork: Edgar Degas, *The Little Fourteen-Year-Old Dancer* (photo 2.1)

Question Sequence

Observation Activity

- Create three gesture drawings of the sculpture from three different angles. A gesture drawing is a very quick (thirty seconds to two minutes) sketch that captures the essence of a subject and is not meant to be realistic. Try to capture the dancer's pose in one or two continuous lines, keeping your hand in motion and your eye on the sculpture.

Observation Question

- What do you notice about this sculpture?

Evidence-Based Inference Activity

- Examine the dancer's pose and facial expression; recreate it with your body. Hold the pose for thirty seconds. How does it feel? What might this figure be thinking or feeling? What makes you say that?

Information

- The title of this artwork is *The Little Fourteen-Year-Old Dancer*. The model for this sculpture was a fourteen-year-old ballet student in Paris named Marie van Goethem.

Interpretation Question

- What do you think we can learn about Marie van Goethem by looking at her portrait?

Lesson Title: The Death of Socrates

Subject Area: Visual Art
Grade: 5th
Author: Lara Tyson
Artwork: Jacques Louis David, *The Death of Socrates* (photo 3.1)
Goals: Students will be able to:

- Examine the choices an artist makes to express a story or idea.
- Make personal connections to a work of art.
- Use evidence-based reasoning to identify the narrative in a work of art.

Essential Question: How do artists tell stories?

Question Sequence

Observation Activities

- *(Provide students with a copy of the painting with just the outlines of the figures. You can create this by using tracing paper against a computer screen and making photocopies.)* Fill in this sketch with the missing objects. What did you find?
- Look closely at the painting and come up with several questions about what you see. Select one question to share with the class. Every student will share their question, but there can be no repetition: if another student asks the same question, you will have to think of a new one.

Evidence-based Inference Questions and Activity

- Frozen tableau activity: Use your body to imitate the gestures of the figures in the painting. Based on their body language, how do you think they feel?
- Who do you think is the main figure in the painting? How can you tell?
- What do you think is the story in this painting? What clues from the painting support your ideas?

Information

This painting is called *The Death of Socrates.* Socrates was a famous teacher in ancient Greece who was sentenced by the government to deny his beliefs or commit suicide by drinking poison. Socrates spoke out against the Athenian government, criticizing their fixation on wealth and physical beauty. He believed only the most intelligent and informed people should lead, and that people should gain knowledge by questioning everything. The Athenian government thought he was corrupting the youth by going against their ideas, so they gave him a choice: either deny your beliefs or die.

- How do you think Socrates feels about his punishment? What details from the painting support this?

Interpretation Questions

- What do you think is the moral of this story?
- Do you agree with Socrates's decision? Why or why not?
- What beliefs, if any, do you think are worth dying for?

Lesson Title: Prove it! Is Mesopotamia a Civilization?

Educator: Christine Sugrue
Subject Area: Social Studies
Class information: Grade 6
Goals: Students will be able to:

- Use primary source artifacts to build understanding of the characteristics of civilization in Mesopotamia.
- Use visual evidence to support their conclusions.

Theme: Mesopotamia
Artworks: *Panels with striding lions* (photos 4.1 and 4.2)

Pre-lesson Activity

Introduce students to the characteristics of a civilization: religion, job specialization, cities, government, language/record keeping system, technology, and social hierarchy.

Question Sequence

Observation Activity

- Sketch what you see.

Observation Question

- What do you notice about this artwork? Turn and talk with a partner.

Information

- The lions were part of a relief leading to the city gates. Lions were associated with Ishtar, the goddess of love and war.

Evidence-Based Inference Question

- What else might these lions represent? What qualities do you associate with lions? Turn and talk with a partner.

Interpretation Question

- What characteristic of a civilization do you think this relief best shows, and why?

Conclusion: *Students return to their sketches and record evidence of the characteristic of a civilization they feel it best represents.*

Pre- or Post-Lesson Activity (for Classroom or Museum)

Display images of artworks from Mesopotamia in the classroom (or visit a museum gallery of Mesopotamian art) and invite students to look closely and write what they see, think, and wonder about each work of art. Next, give students a "coupon" for each of the characteristics of a civilization and invite them to take a second look at the images.

Students will use their coupons to vote on which artwork they think best demonstrates each characteristic of a civilization. Divide students into small groups and assign each group an artwork. In their groups, students will tally the votes for that artwork and discussion the evidence for the winning characteristic.

Lesson Title: Civic Engagement and Art

Educator: Nicole Feliciano
Subject Area: Social Studies
Class information: Grade 6

Goal:

- Students will examine how artists engage in social activism through their work.

Theme: Social Activism and Civic Engagement
Artwork: Jonas Lie, *The Conquerors (Culebra Cut, Panama Canal)* (photo 6.1)

Question Sequence

Observation Question

- Students will make a telescope using a piece of paper and observe the painting closely, switching seats to get a new perspective.

Evidence-Based Inference Questions

- Choose one word that describes the emotion you associate with the painting. Share out.
- What do you think is happening in this painting?

Information

- This painting depicts the construction of the Panama Canal. We are going to learn more about what was going on in Panama during the creation of the canal by reading some historical information.
- Distribute an information sheet about the Panama Canal (see chapter 6 note). In small groups, students turn and talk: what were the advantages and disadvantages of the Panama Canal? After small-group discussion, students share.

Interpretation Questions

- What do you think this artist identified as community problems in Panama at this time?

- What do you think motivated the artist to create this painting?

Lesson Title: The Faces of American Life

Educator: Darnese Olivieri
Subject Area: AP Language and Composition
Class information: Grade 11
Goals: Students will be able to:

- Describe the various perspectives artists have about being "American" based on each artist's depiction of their circumstances, as well as the experiences those circumstances create.
- Develop an argument statement about what it means to be "American" based on their interpretations of the artwork.

Theme/Essential Question: Who is "American?"
Artwork: George Tooker, *Government Bureau* (photo 2.2)

Question Sequence

Provide students with a worksheet with three columns labeled I see, I think, I wonder.

Observation Questions

- Observe the painting for one minute.
- What do you see? Describe what you see in this painting in the "I see" column.
- Underline one thing you listed in the "I see" column. "Popcorn" out responses *(each student shares their idea in one word or phrase, continuing until all students have shared, or the "kernels have popped")*.

Evidence-Based Inference Questions

- What do you think about the painting? Jot down two to three ideas you think about the artwork in the "I think" column.
- What are you curious, confused, or puzzled about? Record your wonderings in the "I wonder" column. Students will share what they think/wonder through *"Pass It" (after sharing their idea, students call on a classmate to respond).*

Interpretation Question

- How would you describe this artist's perspective on American life?

Lesson Title: American Identity

Subject Area: U.S. History
Grade: 11th
Author: Cindy Martinez
Artwork: Winslow Homer, *The Gulf Stream* (photo 1.1)
Essential Questions:

- What are the consequences of dividing a society into hierarchies? (Based on race, gender, class, religion, etc.)
- How can individuals and groups in a democracy organize to correct injustices?

Goals: Students will be able to:

- Identify and describe the consequences of dividing a society into hierarchies based on race and class, including the psychological effects these divisions have on individuals and future generations.

Question Sequence

Observation Questions

- Take a close look at this painting and complete each of the following sentences:

 - I find Surprising…
 - I find Interesting…
 - I find Troubling…

- Share your responses with the class.

Evidence-based Inference Question

- Pretend you are the man in the painting and write a short monologue from his perspective.
- Share your responses with a partner.
- Share your responses with the group.

Information

- The artist, Winslow Homer, created this painting in 1899, during the Reconstruction era.

Interpretation Questions

- What do you think is the meaning of this painting?
- How might this painting comment on the divisions in society based on race?

Lesson Title: Dear Pecola, You Matter!

Subject Area: English
Grade: 12th
Essential Questions:

- Who determines standards of beauty, and how do they affect us?

- How has racism affected the self-esteem of African Americans?

Goals: Students will be able to:

- Think critically about standards of beauty, racism, and self-esteem.
- Deepen their understanding of the themes of Toni Morrison's *The Bluest Eye* through engaging with works of art.*

*This lesson is intended for students who have completed or are in the midst of reading *The Bluest Eye*.

Artwork: *La Capresse des Colonies* (photo 0.3)

Question Sequence

Observation Question

- Describe what you see.

Evidence-based Inference Activity

- Choose one word you think of when looking at this artwork. Write that word on an index card. Pass your card to another person and read their word. Look at the sculpture, figure out why that person wrote the word, and write what you see that justifies this word. Share your response with the class.

Interpretation Question

- Assume the persona of the subject of this sculpture. Write a letter from her to Pecola, the protagonist of *The Bluest Eye*. What message do you think she would pass on to Pecola? Share your response with the class.

Additional Teaching Resources from The Met

Laura Smith's lesson on *Esther before Ahasuerus* (photo 0.1): https://www.metmuseum.org/learn/educators/lesson-plans/fortunes-fool
Met Museum Curriculum Resources: https://www.metmuseum.org/learn/educators/curriculum-resources
The Metropolitan Museum of Art's Heilbrunn Timeline of Art History: https://www.metmuseum.org/toah/
Met Museum Lesson Plans: https://www.metmuseum.org/learn/educators/lesson-plans

Online Resources for Teaching with Works of Art

Museum websites are the best resources for researching and finding high-resolution images of works of art to teach from in the classroom. Here are links to the collection pages of five great art museums in New York City:

Metropolitan Museum of Art: https://www.metmuseum.org/art/collection
Brooklyn Museum: https://www.brooklynmuseum.org/opencollection/collections
Studio Museum of Harlem: https://www.studiomuseum.org/collection
Whitney Museum: http://collection.whitney.org/
Museum of Modern Art (MoMA): https://www.moma.org/collection/

Note

1. West, Kanye (@kanyewest). n.d. "I feel like if I had to be defined at this point I'll take the title of an inventor or maybe curator." Twitter, tweet deleted by user. Archived in "Rediscovering Kanye West's Lost Art and Design Tweets," Complex, June 7, 2013. https://www.complex.com/style/2013/06/kanye-west-tweets/.

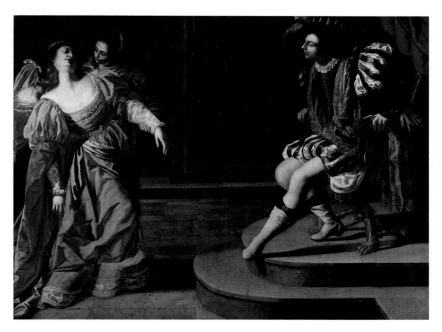

Photo 0.1: Artemisia Gentileschi (Italian, born Rome 1593–died Naples 1654 or later).
Esther before Ahasuerus. *Oil on canvas; 82 × 107¾ in. (208.3 × 273.7cm).*
The Metropolitan Museum of Art, New York. Gift of Elinor Dorrance Ingersoll, 1969 (69.281).

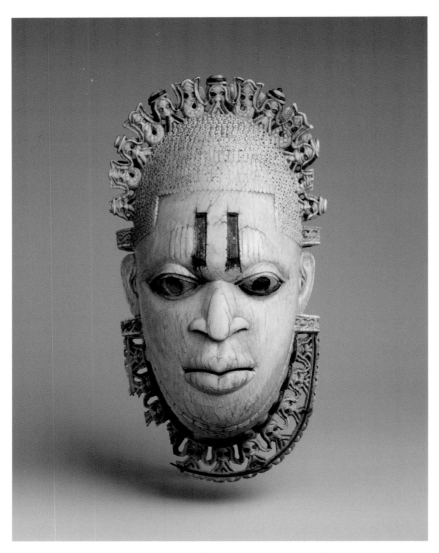

Photo 0.2: Queen Mother Pendant Mask: Iyoba, *16th century. Nigeria, Court of Benin, Edo. Ivory, iron, copper (?); H. 9³/₈ × W. 5 × D. 3¹/₄ in. (23.8 × 12.7 × 8.3 cm).*
The Metropolitan Museum of Art, New York. The Michael C. Rockefeller Memorial Collection. Gift of Nelson A. Rockefeller, 1972 (1978.412.323).

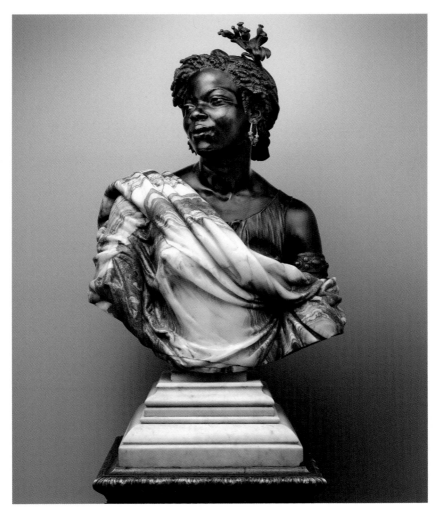

Photo 0.3: Charles-Henri-Joseph Cordier (French, 1827–1905), pedestal attributed to designs by Charles-François Rossigneux (French, 1818–after 1909). La Capresse des Colonies, 1861. Algerian onyx-marble, bronze and gilt bronze, and enamel; white marble socle. Overall on socle (confirmed): H. 37¾ × W. 23¼ × D. 12¼ in., 208.4 lb. (95.9 × 59.1 × 31.1 cm, 94.5296 kg) [weight breakdown: head 35.4 lbs., marble bust 173 lbs., marble socle 98.7 lbs.]; pedestal (confirmed): H. 41³/₈ × W. 18¼ × D. 18¼ × 11¾ in. (105.1 × 46.4 × 46.4 × 29.8 cm).

The Metropolitan Museum of Art, New York. European Sculpture and Decorative Arts Fund, 2006 (2006.112a–c).

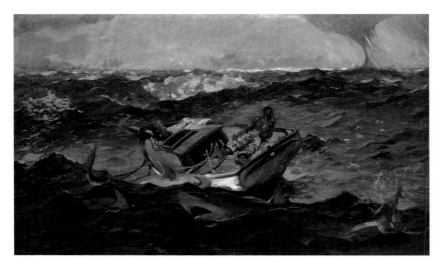

Photo 1.1: Winslow Homer (American, Boston, Massachusetts 1836–1910 Prouts Neck, Maine). The Gulf Stream, *1899. Oil on canvas; 28$^1/_8$ × 49$^1/_8$ in. (71.4 × 124.8 cm).*

The Metropolitan Museum of Art, New York. Catharine Lorillard Wolfe Collection, Wolfe Fund, 1906 (06.1234).

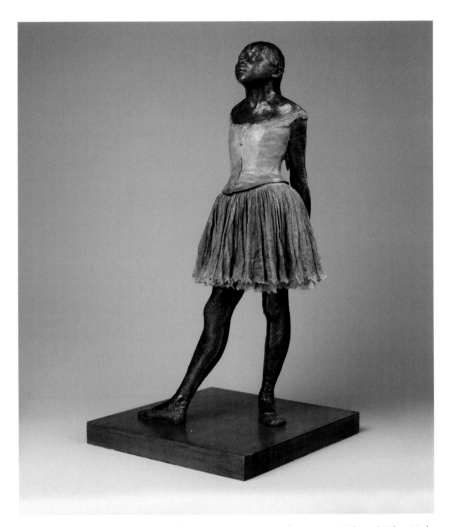

Photo 2.1: Edgar Degas (French, 1834–1917); cast by A. A. Hébrard. The Little Fourteen-Year-Old Dancer, *model executed ca. 1880, cast 1922. Bronze, partially tinted, with cotton skirt and satin hair ribbon; wood base; overall: 38½ × 17¼ × 14³⁄₈ in. (97.8 × 43.8 × 36.5 cm).*

The Metropolitan Museum of Art, New York. H. O. Havemeyer Collection. Bequest of Mrs. H. O. Havemeyer, 1929 (29.100.370).

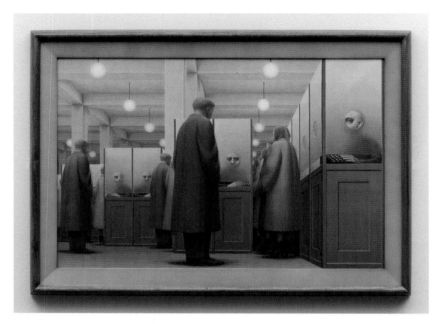

Photo 2.2: George Tooker (American, Brooklyn, New York 1920–2011 Hartland, Vermont). Government Bureau, 1956. Egg tempera on wood; 19⅝ × 29⅝ in. (49.8 × 75.2cm).

The Metropolitan Museum of Art, New York. George A. Hearn Fund, 1956 (56.78).

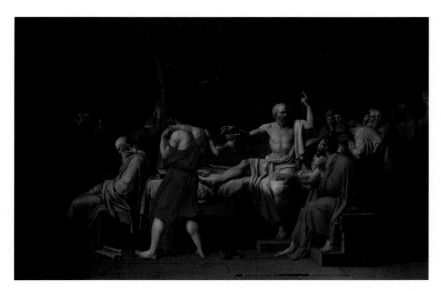

Photo 3.1: Jacques Louis David (French, Paris 1748–1825 Brussels). The Death of Socrates, *1787. Oil on canvas; 51 × 77¼ in. (129.5 × 196.2 cm).*

The Metropolitan Museum of Art, New York. Catharine Lorillard Wolfe Collection, Wolfe Fund, 1931 (31.45).

Photos 4.1, 4.2: Panel with striding lion, *ca. 604–562 BC. Mesopotamia, Babylon (modern Hillah). Ceramic, glaze; 38.25 × 89.5 in. (97.16 × 227.33 cm).*
The Metropolitan Museum of Art, New York. Fletcher Fund, 1931 (31.13.1, 31.13.2).

Photo 5.1: Mark Rothko (American [born Russia], Dvinsk 1903–1970 New York).
No. 16, 1960. Oil on canvas; 102 × 119½ in. (259.1 × 303.5 cm).

The Metropolitan Museum of Art, New York. Arthur Hoppock Hearn Fund, George A. Hearn Fund and
 Hugo Kastor Fund, 1971 (1971.14). © 1998 Kate Rothko Prizel & Christopher Rothko / Artists Rights
 Society (ARS), New York.

Photo 6.1: Jonas Lie (American, 1880–1940). The Conquerors (Culebra Cut, Panama Canal), *1913. Oil on canvas; 60 × 50 in. (152.4 × 127 cm).*
The Metropolitan Museum of Art, New York. George A. Hearn Fund, 1914 (14.18).

Photo 7.1: Ancestor Figure (Konumb or Atei), 19th century. Papua New Guinea, Lower Sepik River; Kopar or Angoram. Wood, paint; H. 73 × W. 8 × D. 3½ in. (185.4 × 20.3 × 8.9 cm).

The Metropolitan Museum of Art, New York. The Michael C. Rockefeller Memorial Collection. Gift of Nelson A. Rockefeller, 1969 (1978.412.727).

Photo 7.2: Alexander Calder (American, Philadelphia, Pennsylvania 1898–1976 New York). Red Gongs, *1950. Painted aluminum, brass, steel rod, and wire; 60 in. × 12 ft. (152.4 × 365.8 cm); Weight: 9.7 lb. (4.4 kg).*

The Metropolitan Museum of Art, New York. Fletcher Fund, 1955 (55.181.1a-f). © 2018 Calder Foundation, New York / Artists Rights Society (ARS), New York.

Photo 9.1: Pectoral and Necklace of Sithathoryunet with the Name of Senwosret II, *Middle Kingdom, Dynasty 12, reign of Senwosret II, ca. 1887–1878 BC. From Egypt, Fayum Entrance Area, Lahun, Tomb of Sithathoryunet (BSA Tomb 8), BSAE excavations 1914. Gold, carnelian, lapis lazuli, turquoise, garnet (pectoral); gold, carnelian, lapis lazuli, turquoise, green feldspar (necklace); L. of necklace (b): 82 cm (32⁵/₁₆ in.); H. of pectoral (a): 4.5 cm (1¾ in.); W. 8.2 cm (3¼ in.).*

The Metropolitan Museum of Art, New York. Purchase, Rogers Fund and Henry Walters Gift, 1916 (16.1.3a, b).

Photo 9.2: Funerary Mask, *AD 900–1100. Peru, Chornancap, Lambayeque; Sicán. Gold, silver-copper overlays, cinnabar; H. 11½ in. × W. 19½ in. × D. 4 in. (29.2 × 49.5 × 10.2 cm).*

The Metropolitan Museum of Art, New York. Gift and Bequest of Alice K. Bache, 1974, 1977 (1974.271.35).

Photo 9.3: Mickalene Thomas. Le Déjeuner Sur L'herbe: Les Trois Femmes Noires, *2009. Rhinestone, acrylic and enamel on panel; 120 × 288 × 2 in. (304.8 × 731.5 × 5.1 cm).*

© 2018 Mickalene Thomas / Artist Rights Society (ARS), New York. Courtesy the artist and Lehmann Maupin, New York and Hong Kong.

Photo 9.4: Edouard Manet (1832–1883). Le Déjeuner sur l'herbe, *1863. Oil on canvas; H. 208 cm; W. 264.5 cm.*

Musée d'Orsay, Paris. Photo © RMN-Grand Palais (Musée d'Orsay) / Hervé Lewandowski.

About the Author

Nicola Giardina has devoted her career to creating powerful learning experiences for K–12 students and teachers using works of art. In 2014, she was honored to receive a fellowship at The Metropolitan Museum of Art, where she led professional learning communities for forty-five New York City teachers from Title 1 and Districts 75 and 79 public schools. Through her experiences as an arts integration specialist, art teacher, and museum educator, Nicola has gained expertise in how students learn through art and how teachers can effectively leverage the power of art to support all learners. Her unique, research-based framework for art integration, the Pyramid of Inquiry, has been adopted by educators at The Metropolitan Museum of Art, as well as many New York City public schools.